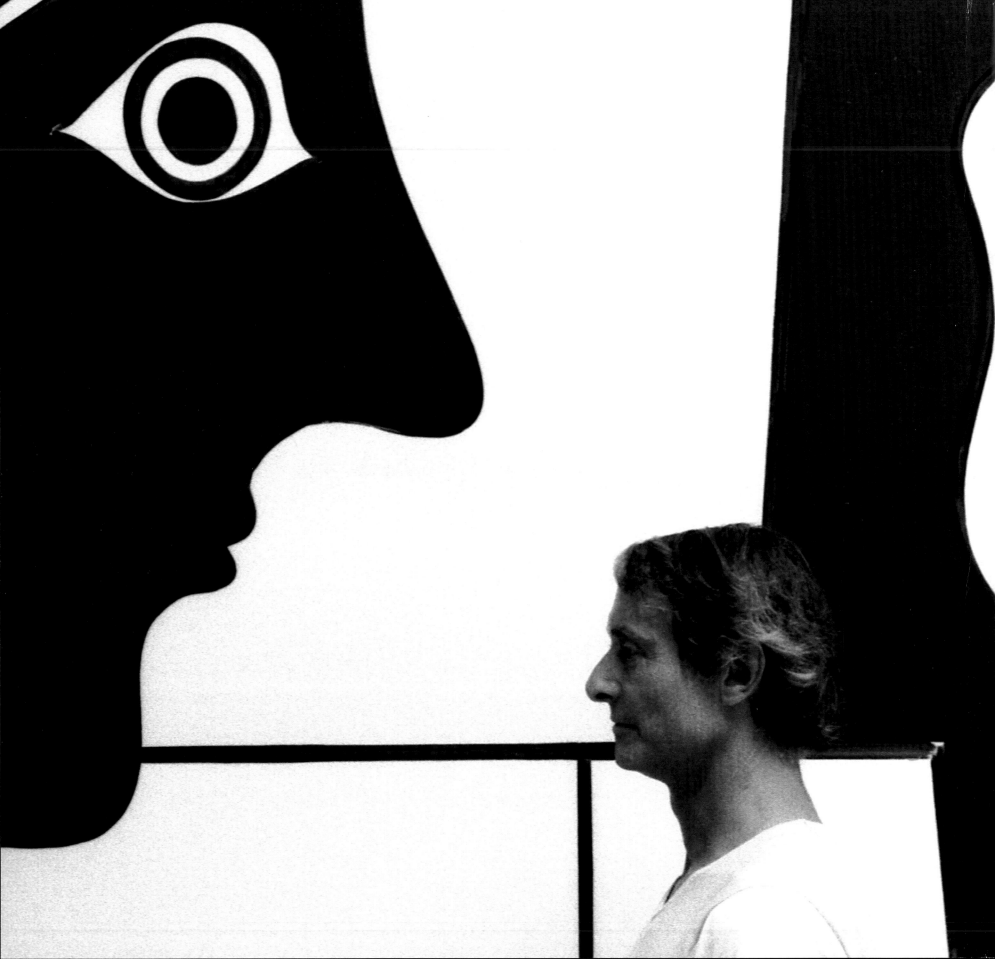

ROY LICHTENSTEIN

CONVERSATIONS WITH SURREALISM

MITCHELL-INNES & NASH

PAINTINGS, DRAWINGS, AND PASTELS

A Thesis

Presented in Partial Fulfillment of the Requirements

for the Degree Master of Fine Arts

by

ROY FOX LICHTENSTEIN, B.F.A.

1949

Approved by:

Hoyt L Sherman

Adviser

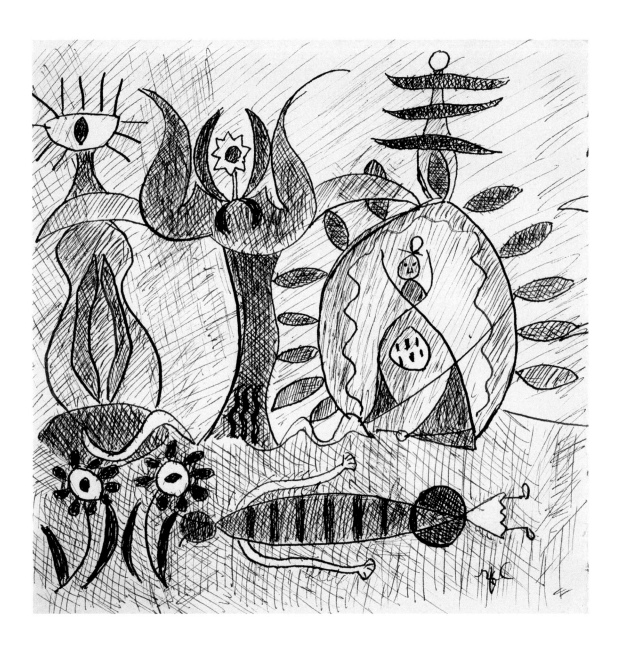

Generally recognized is the great difficulty in approaching an understanding of painting through the medium of words. The many volumes of work on the subject testify to this. It is my belief, however, that paintings themselves embody the process and direction through which they are achieved. The enclosed paintings, though recently done, are the result of extensive study in the field of painting, and are considered to represent the bulk and importance of this thesis.

Therefore, no formal attempt is made to analyse my own art form, or to analyse the qualities intrinsic to painting generally; but the following written portion of this thesis is presented in the form of a general expression of my feelings about painting.

Art is mysterious, but definable.

It is mysterious as a thing,

But definable as a way.

But mysterious as a thing

Only when the way isn't known;

But, too, it forever remains

Mysterious as a way;

But not so much

And less and less, until,

Finally, you can say,

It isn't so mysterious;

Yours, only slightly;

Others, more.

So the ways of art are definable

More and more.

<p align="center">* * *</p>

Artways are apparent, but concealed.

They are apparent

In that they are your natural ways;

But hidden from you,

Because Today has forced you from

These natural ways,

And home is now strange.

In awe, then, you must sing

An Ode to the Wonderful Wizards of Art:

Sing of Klee's secret glee,

And of Picasso's electric expression,

And, of Braque,

Bright, with even effort,

Neither so good nor so bad as Picasso,

And sing, too, of Rousseau's tigers brightly burning,

Of Rousseau's

I spy you,

Hiding in the dark,

Weird mystery,

And sing of stolid Cezanne,

And praise the mad Van Gogh,

And sing of Gauguin's magic,

Though you'd rather be bewitched by Rousseau.

Still, sing without reserve.

Their enchantment is real.

Even understanding can't dissipate intrigue;

But the mystery thickens as you dispel it.

Look at that Matisse!

Open your eyes wide!

Talk about design, color, and composition,

And split into many entities the whole

(Which the Great Ones wry their shoulders to force out);

And, with a knowing wink,

Lock it up tight again,

With praise for the <u>work</u>,

One and indistructable.

It is through acting that you come to know,

And constant talk may yield

Great understanding;

But, if it doesn't,

Try you hand,

Which is joined to your arm,

Then, to your shoulder and back,

And then, more directly than you realize,

To your viscera.

* * * *

Therefore, you must use your hand

To make the felt thing seen,

Rather than your eyes

To see to say.

Nor can you **feel** what you have seen

Until you see what you have felt.

The truth of nature's structure

Comes to you through work,

And is then projected through your eyes.

So looking without touching would uncover for you

None of the world's structure,

And things would remain only

Incomprehensible colors;

But you could fathom out

And understand the existence of things

With touch alone.

You must first feel, then see.

You must feel until you see.

You will see what you feel.

<center>* * *</center>

Once, you wanted desperately to play

With your cribtoys to understand them

And to give them being.

Today, therefore, you think you know

The thick and rounded world.

In the same way now,

You must want to play with painting

To strain out its flat and different world.

You must make the flat world

Explain again the full world to you.

<center>* * *</center>

You can't understand how the cyclops saw

In the generalization of the mist

Merely by peering

With one closed eye.

But you will approach his vision

In kind, and on your ground.

As you, with one eye closed,

Play as the cyclops played.

* * *

Nor can you see what Cezanne saw

In nature or on canvass

by merely looking.

Cezanne acted to see.

You must act as Cezanne.

Cezanne acted as Lautrec.

Lautrec acted as Rembrandt.

Rembrandt acted as Ma Yuan.

Ma Yuan acted as you did

When you were young;

But Today has forced you from

These natural ways,

And home is strange to you now.

* * *

Go back?

You can't.

Act as Lautrec?

You can't.

But you must approach him more and more;

But only in the way he approached Rembrandt.

In commonness you communicate.

In identity you lose your magic.

In seeking the way of art you must retain

Your purpose: To understand yourself,

And to understand others through yourself,

And not just to understand others,

And not just to understand Cezanne.

You're looking for the painters' common action,

Through which they know each other,

And through which they achieve art.

<center>* * *</center>

Where should you set yourself to act?

How should you see?

What should you believe?

You must set yourself to <u>feel</u>

Until you see the way the cyclops saw

In the generalization of the mist!

Reach for reality!

<center>* * *</center>

You need freedom;

But freedom, itself,

Won't result in art action.

You must have control;

But control toward no profitable purpose

Won't bring you to art action.

Your personal makeup is your freedom.

It frees you from others

As you differ from others.

Your purpose is your control.

Your control is your constant fight

Toward a more rewarding way of knowing yourself.

Your control brings you closer to others

Who fight toward a more rewarding way,

For the routes converge as they reach

A more rewarding way,

And it remains mysterious as a way

Not so much,

And less and less, until,

Finally, you can say,

It isn't so mysterious;

Yours, only slightly;

Others, more.

BIBLIOGRAPHY

Rewald, John. _Gauguin's Letters._ Edited by John Rewald.
 San Francisco: The Grabhorn Press, 1943.

Delacroix, Eugene. _The Journal of Eugene Delacroix._
 Translated from the French by Walter Pach.
 New York: Covici, Friede Co., 1937.

Dewey, John. _Art as Experience_. New York: Minton, Balch
 and Co., 1943.

Gogh, Vincent van. _Dear Theo_. Edited by Irving Stone.
 Boston; Houghton Mifflin Co., 1937.

Soby, James Thrall. _George Rouault._ Edited by James
 Thrall Soby. New York: The Museum of Modern
 Art, 1945.

Miller, Margaret. _Paul Klee_. Edited by Margaret Miller.
 New York: The Museum of Modern Art, 1945.

Sweeney, James Johnson. _Alexander Calder_. Edited by
 James Johnson Sweeney. New York: The
 Museum of Modern Art, 1943.

Sherman, Hoyt L. _Drawing by Seeing_. New York: Hinds,
 Hayden and Eldredge. 1947.

Schaeffer-Simmern, Henry. _The Unfolding of Artistic
 Activity_. Berkeley and Los Angeles: University
 of California Press, 1948.

Lowenfeld, Viktor. _Creative and Mental Growth_. New
 York: The Macmillan Company, 1947.

Barr, Alfred H. Jr. Picasso, _Fifty Years of his Art_.
 Edited by Alfred H. Barr Jr. New York:
 The Museum of Modern Art, 1946.

Langer, Susanne K. _Philosophy in a New Key_. Cambridge,
 Mass.: Harvard University Press, 1942.

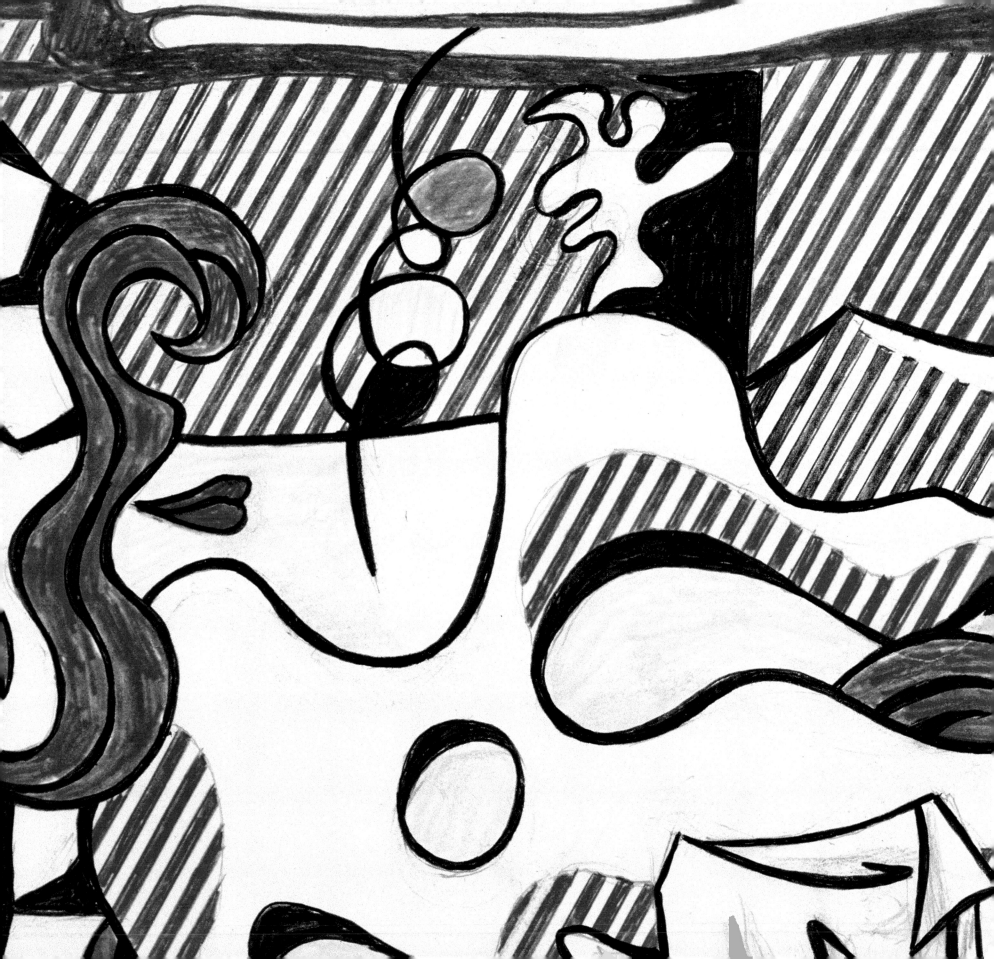

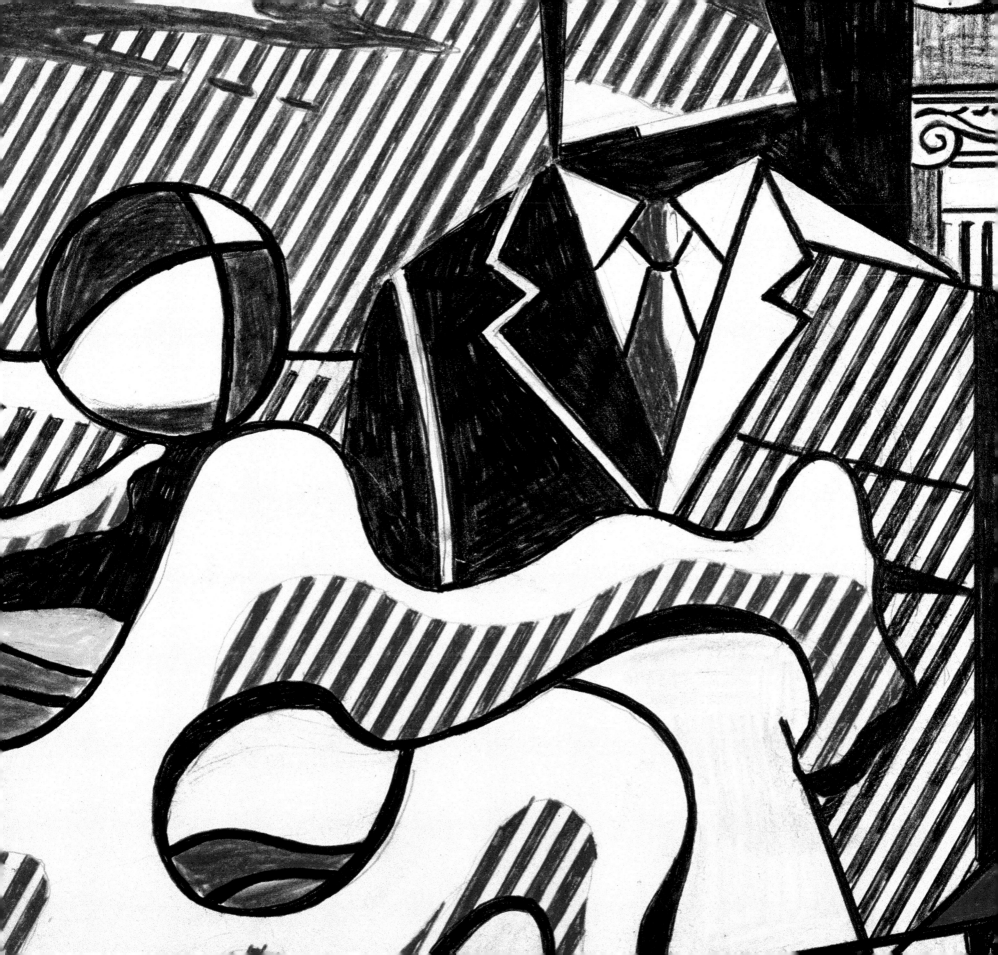

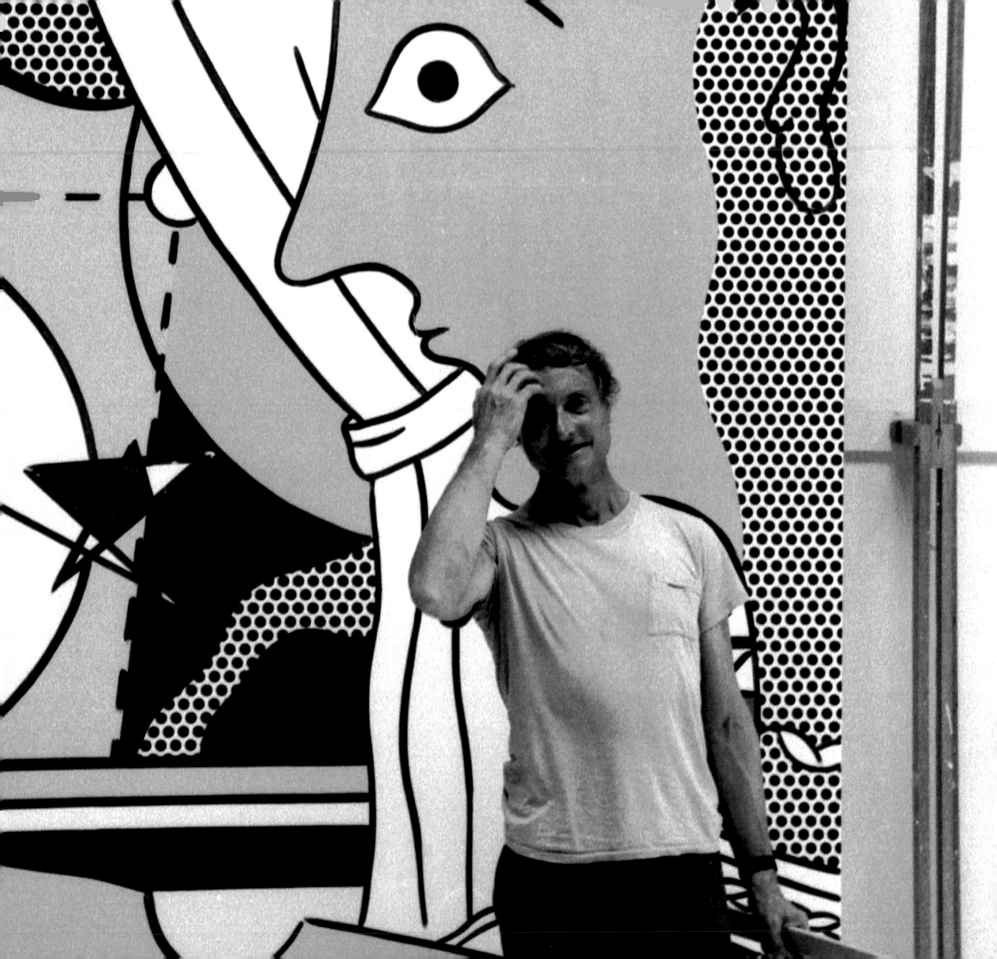

DRAWINGS

FIRST & OTHER THOUGHTS Jack Cowart

Roy Lichtenstein always drew: caricatures, snippets, details, plans for paintings, constructions, projects consciously rough – blocked in and independent images. He drew to paint or sculpt or print or design. Two-dimensional drawing was inherent in everything he did and his drawings remain his best autograph. The vast majority of the small rectangular properly scaled drawings extant today were made to be projected through the poor quality enlarger obliging a new and re-creative re-drawing (underdrawing) directly on canvas for paintings or on foamcore to make collage outlines for prints and sculpture. Everything finished began with these drawings. One has to know both and all the in-between stages, even if the artist did his best to camouflage the labor and delivery of the end product. I wish we knew what he threw away. There must have been many drawings that didn't result in a work, which had no next purpose, which he "disappeared," covering his tracks.

I like to think that many of his drawings were made at night, privately, meditatively. Their personal intimacy, pentimenti and reductivist scale set them apart from all the public Lichtensteins. The drawings were occasioned by his seeing or thinking or dreaming about a different illustrated work of art, or his own work, or the intertwined accumulation of source material, or as a way to be distracted but still feel disciplined and productive. Most drawing sheets started in portfolios or sketchbooks. Sketches would be cut out for projection and then pinned up beside the painting or collage, as a vaguely related *premiere pensée* or *aide mémoire* or maybe really the primary thing he always wanted to try to get back to. I don't know why, but French words slip in when I think of his drawings, maybe it a Matissian nostalgia.

By category there are various art historical subsets of these drawings: general sketches; combinant/recombinant rough studies; variant studies; drawn and collaged interim studies; finished studies and then what I call "presentation drawings" – those larger scale beautifully confected works seemingly made for joy and pleasure, those big drawings closest to the big paintings. We still have a long way to go to figure out the hows and whys of all the rest.

2

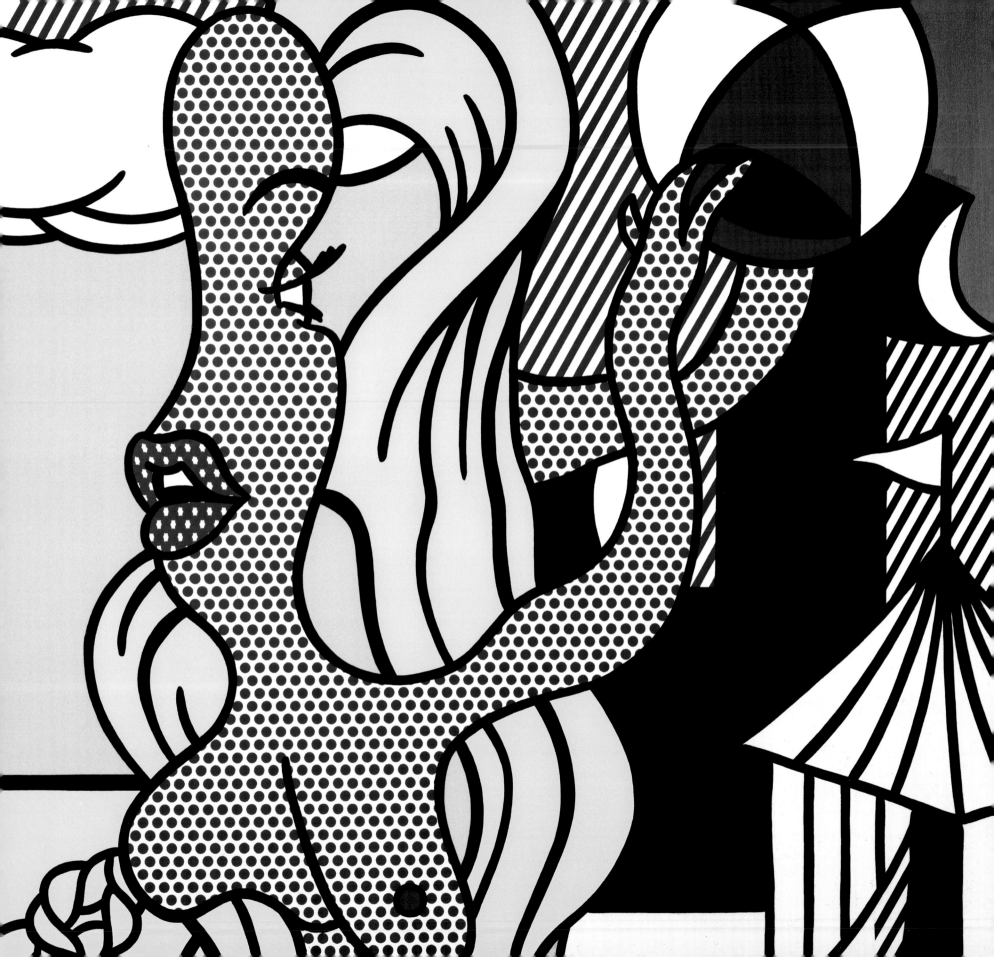

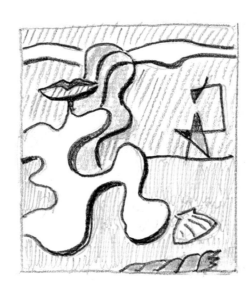

4

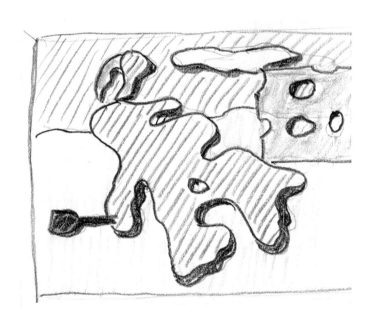

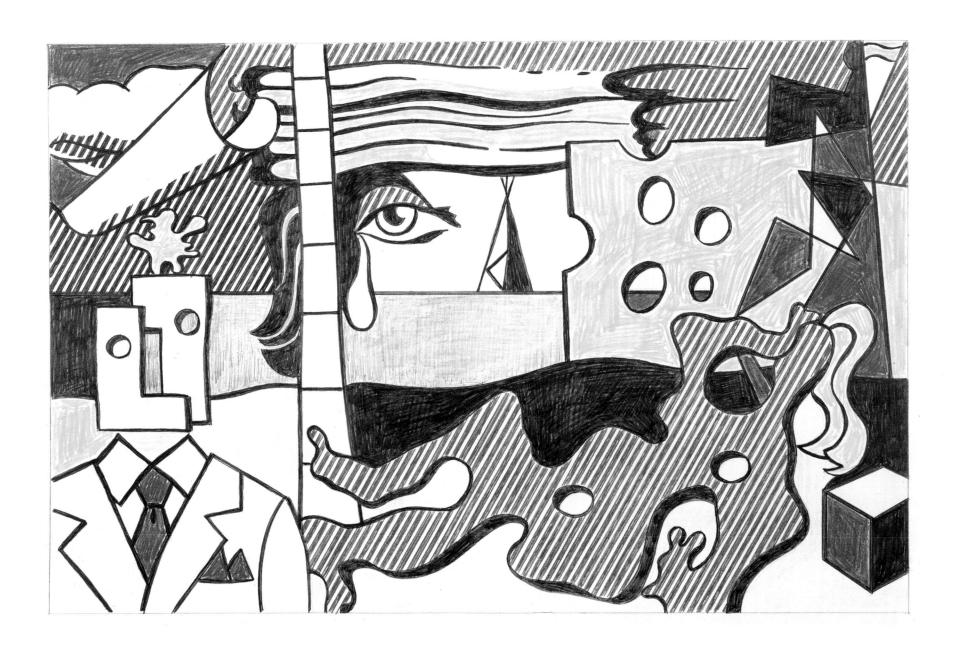

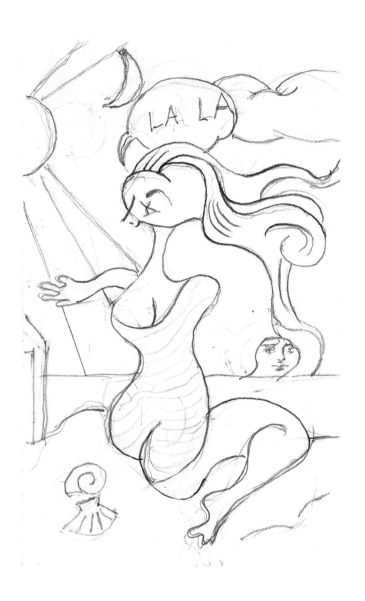

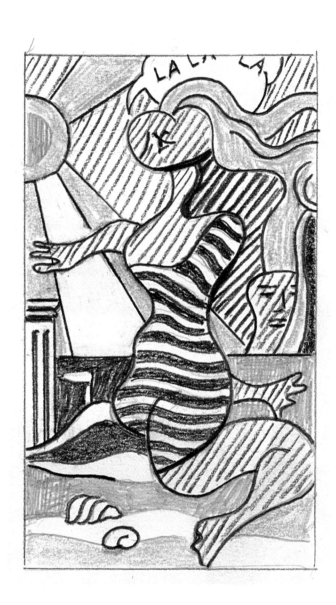

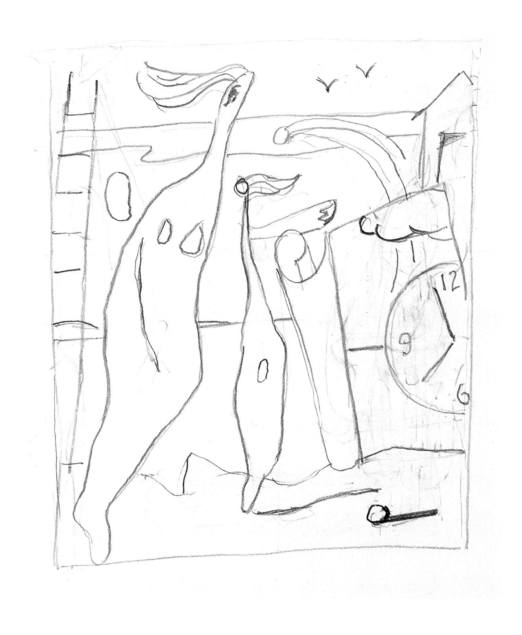

9

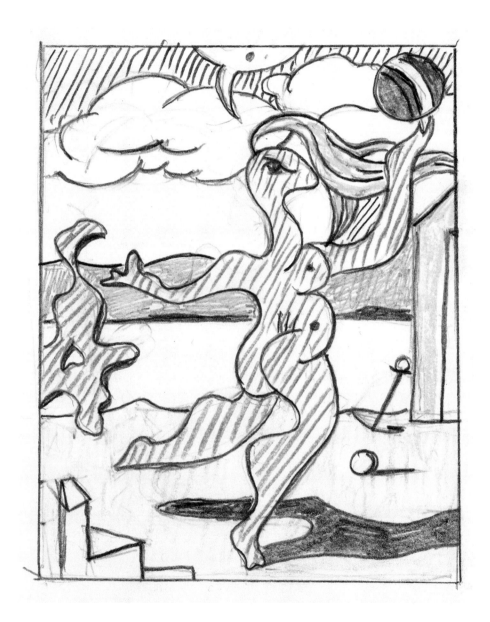

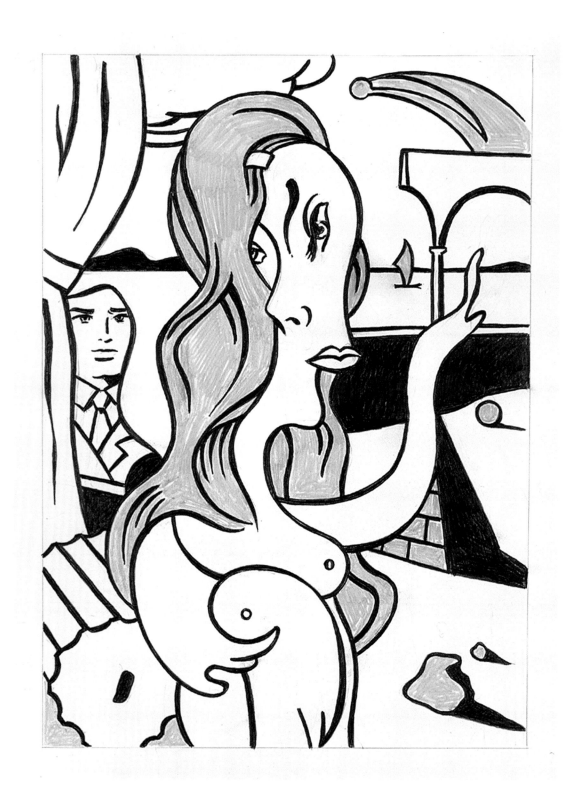

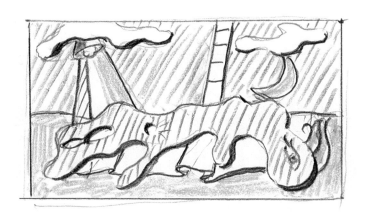

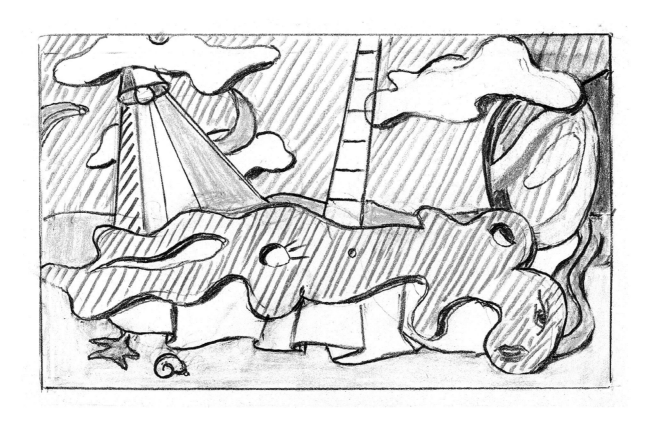

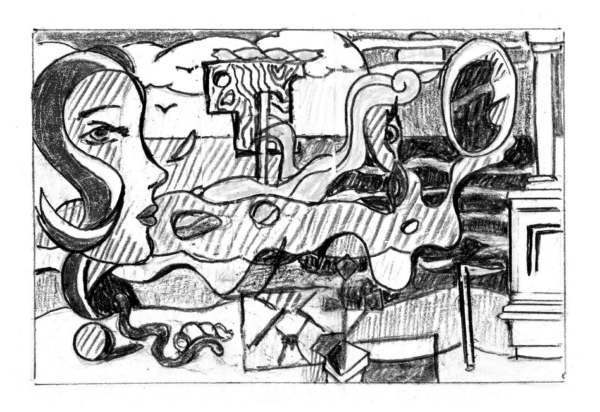

14

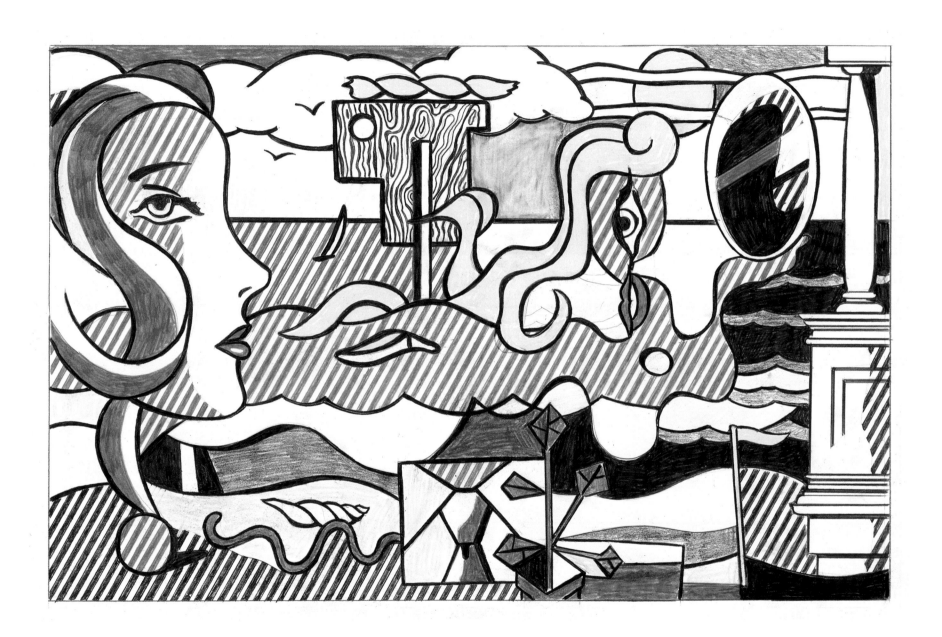

15

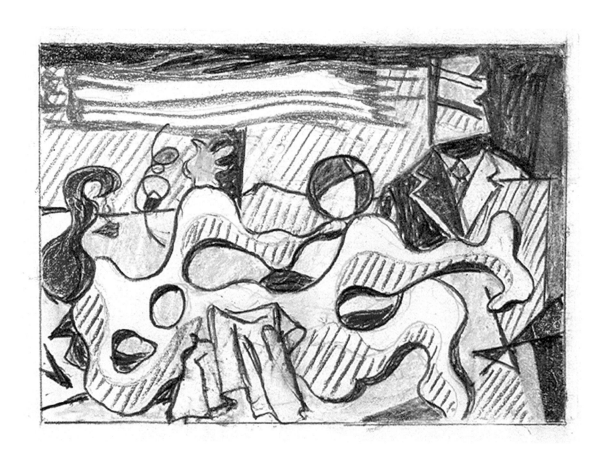

16

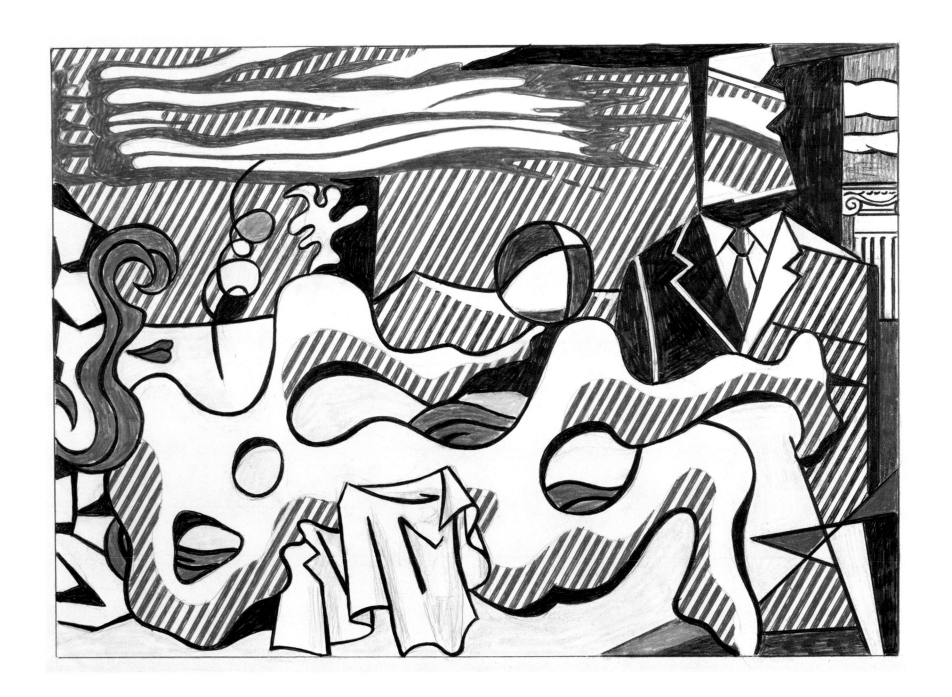

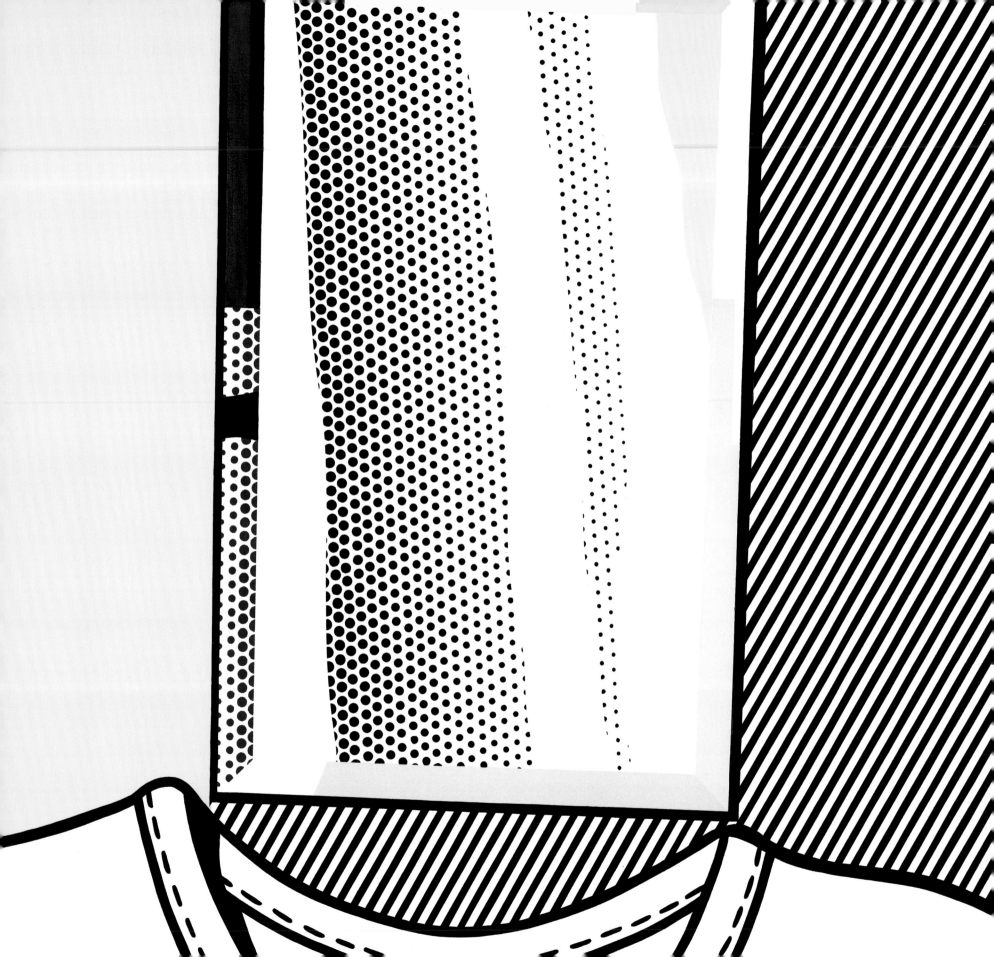

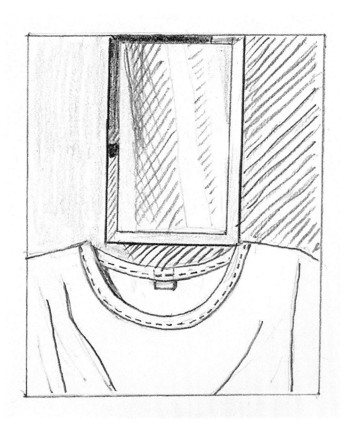

18

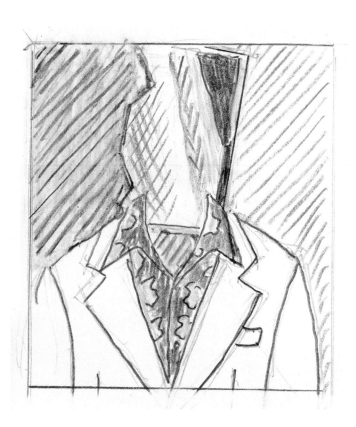

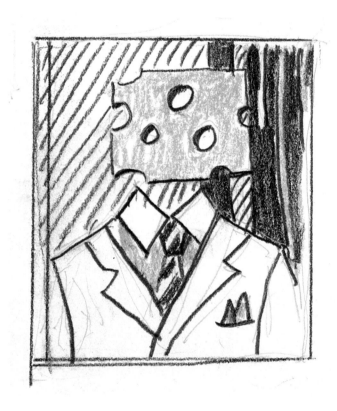

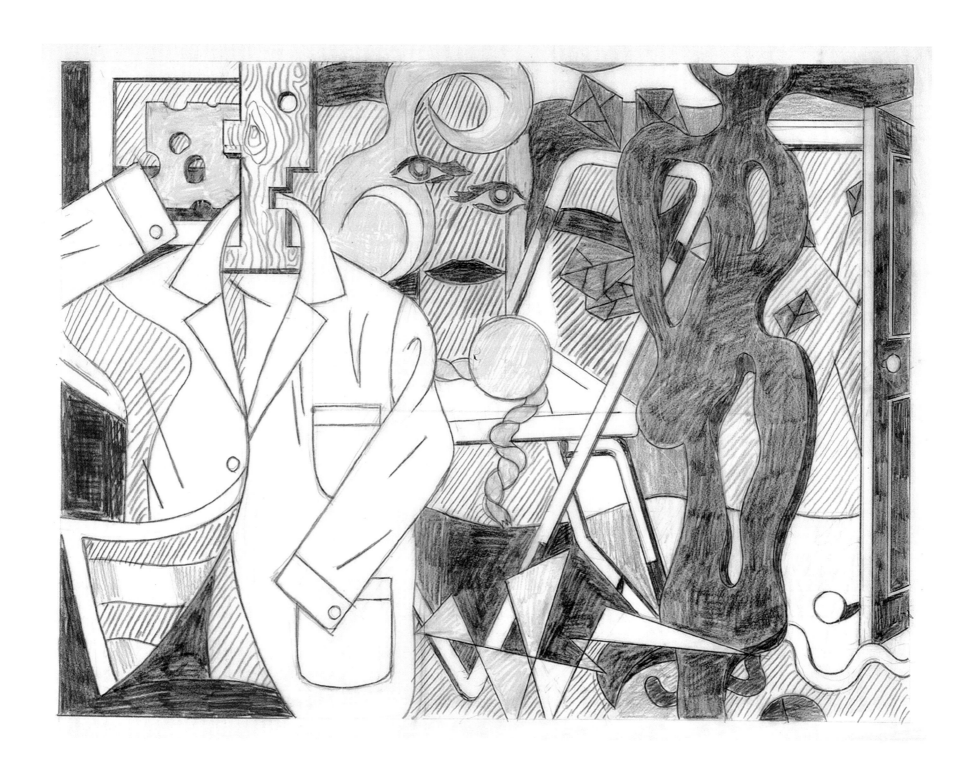

21

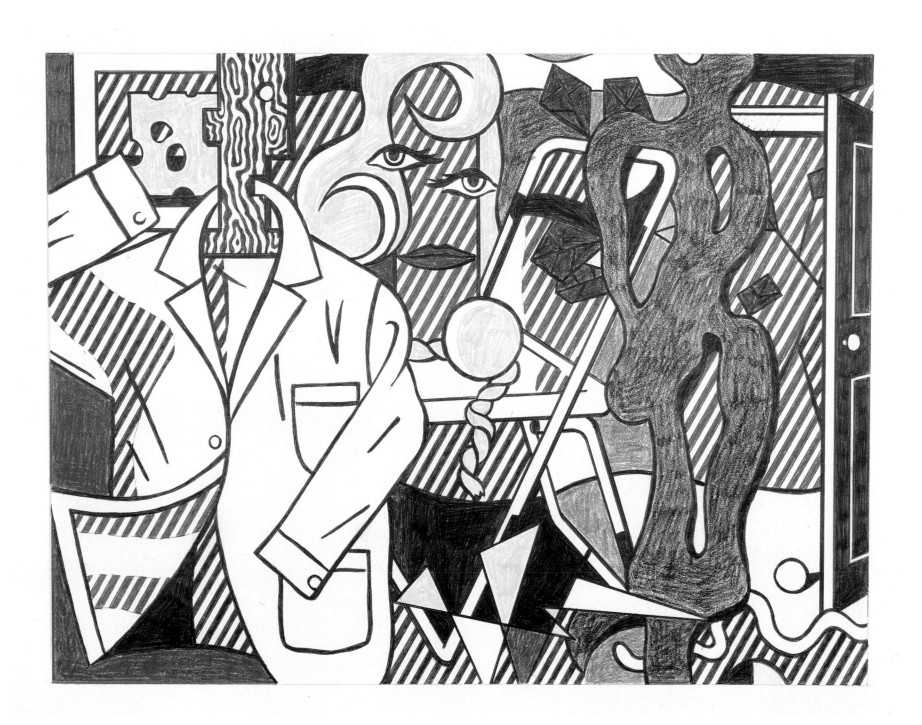

22

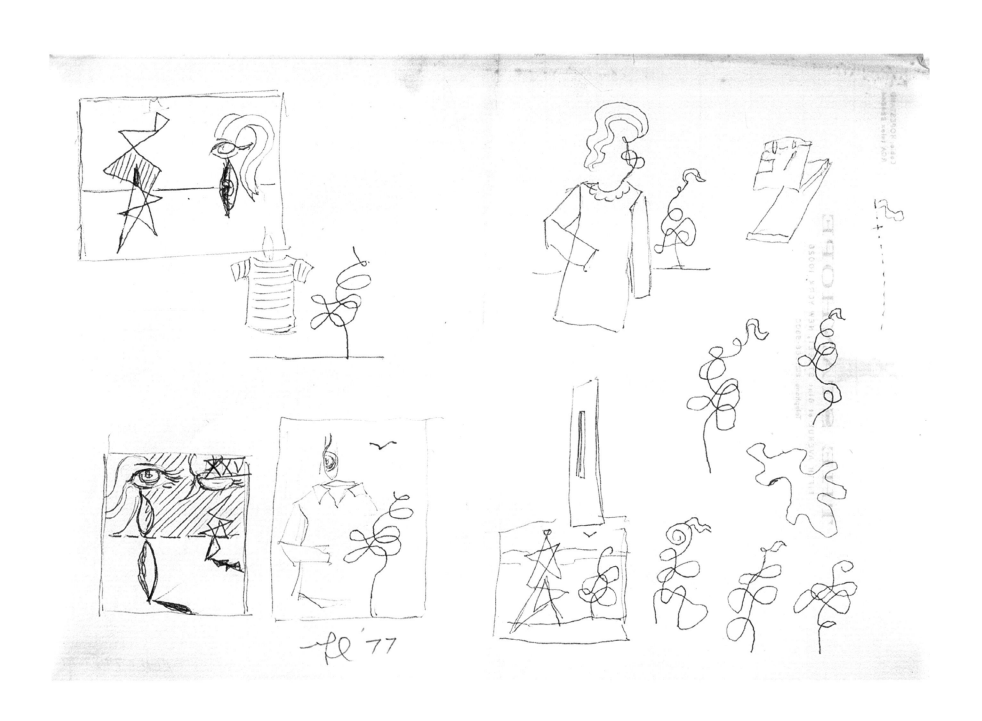

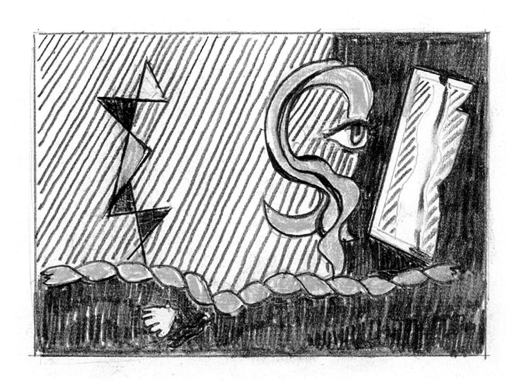

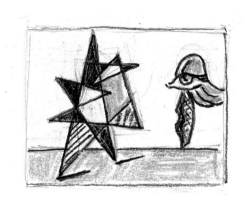

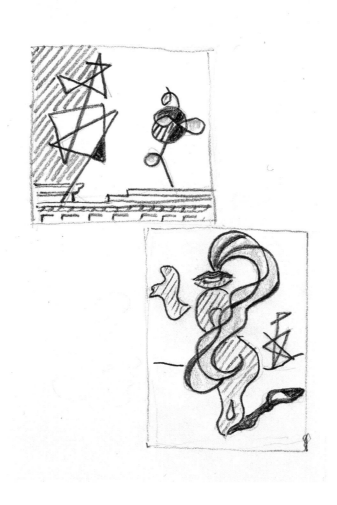

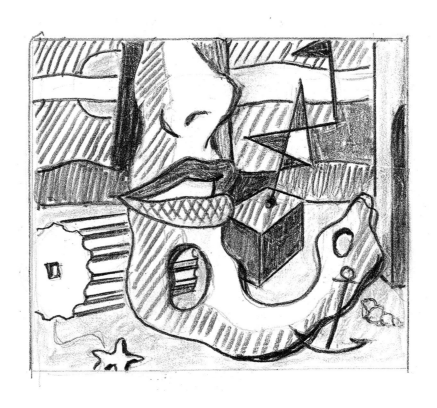

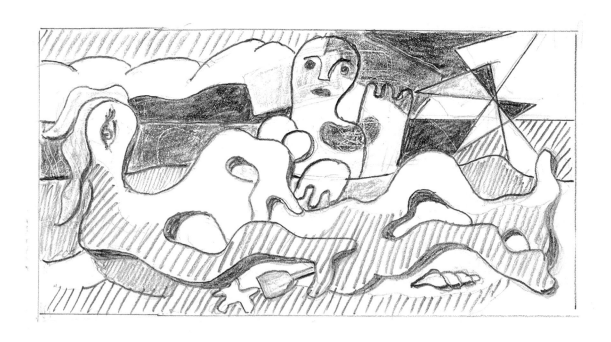

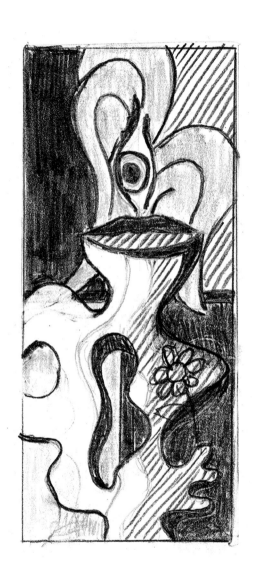

29

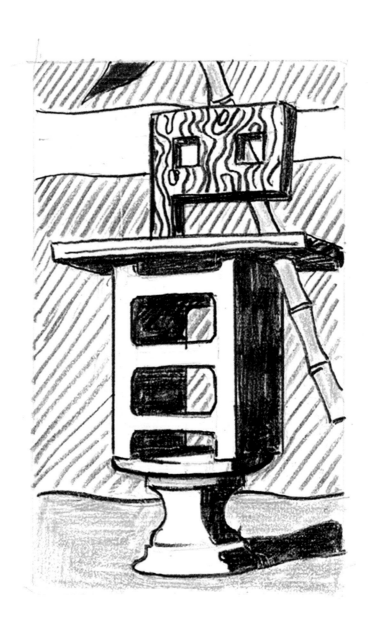

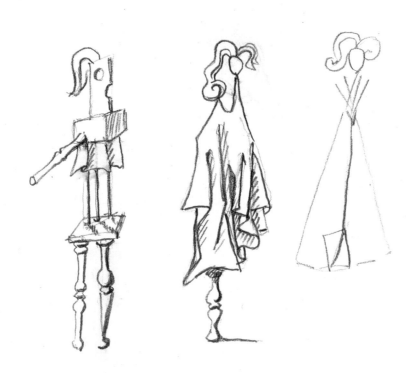

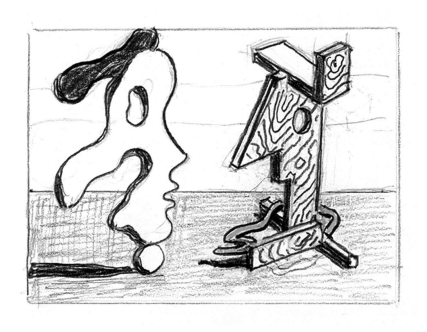

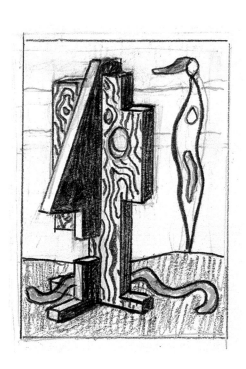

32, 33

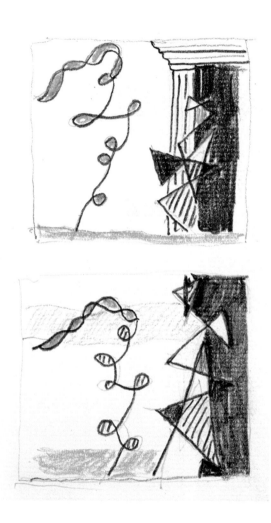

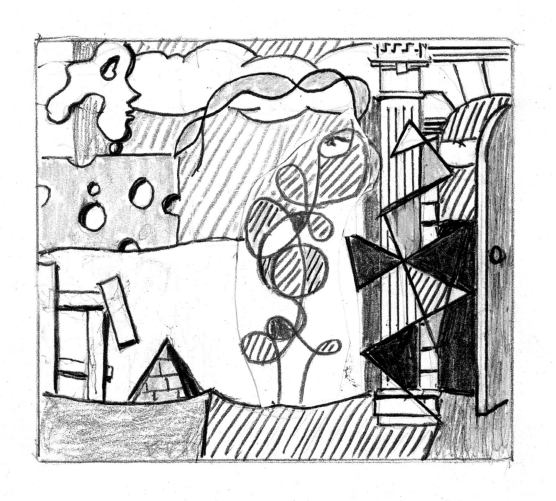

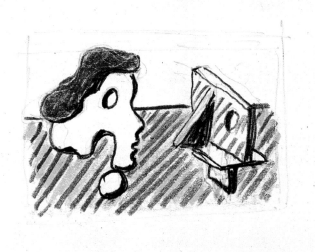

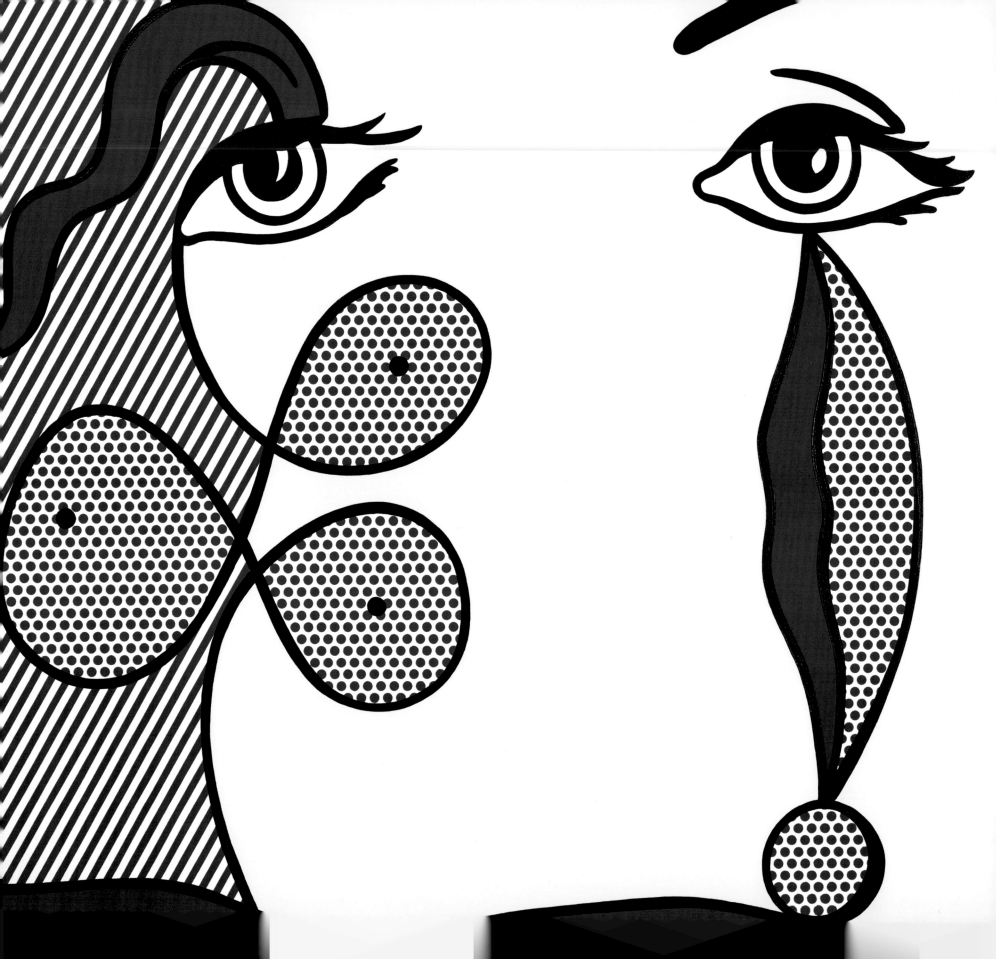

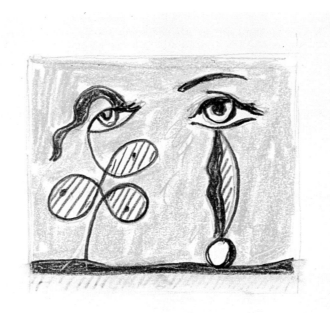

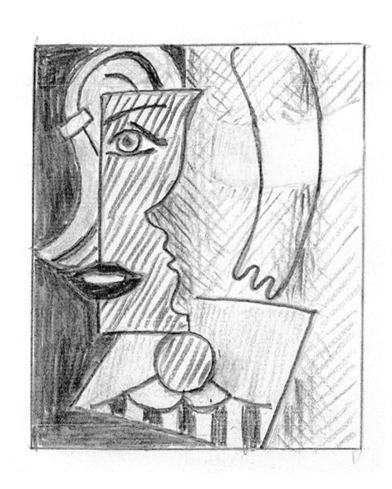

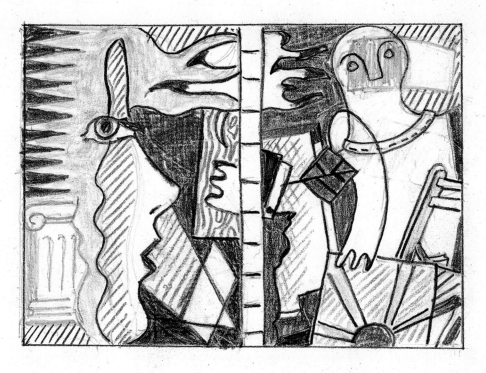

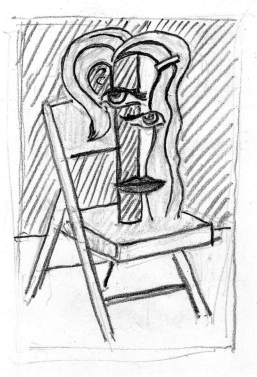

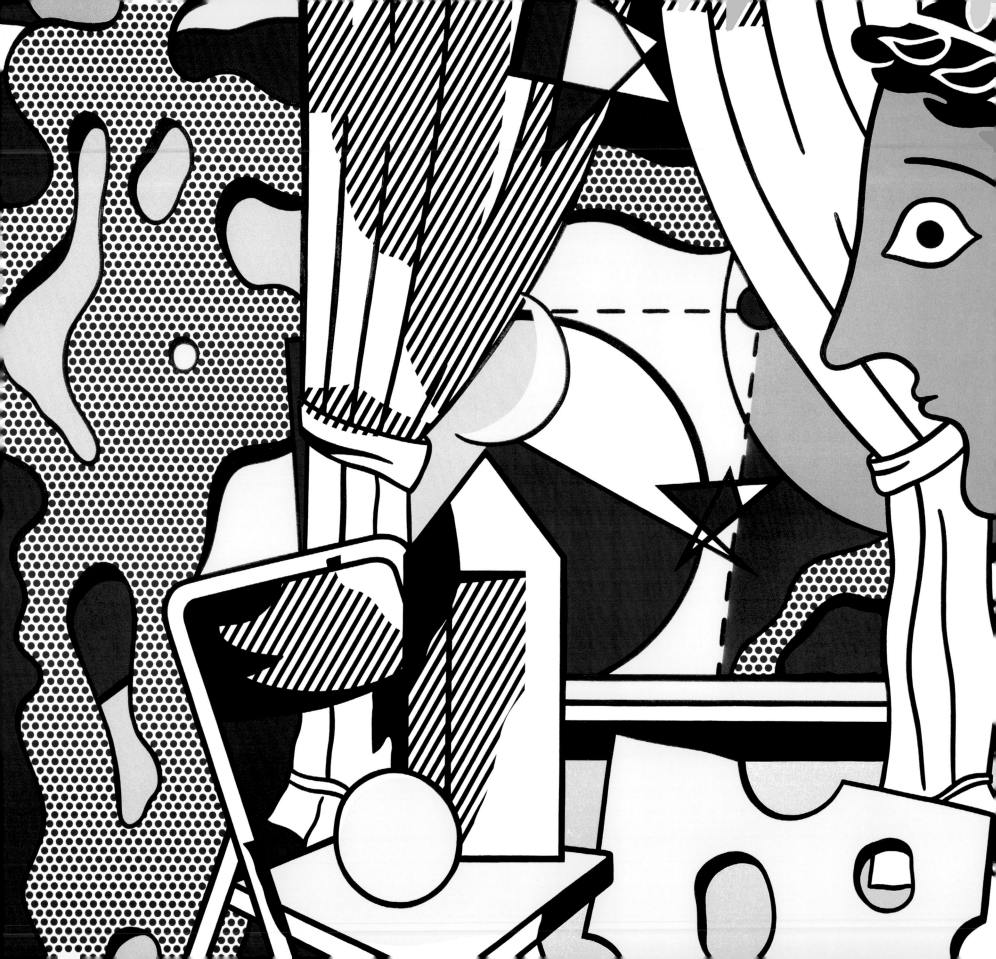

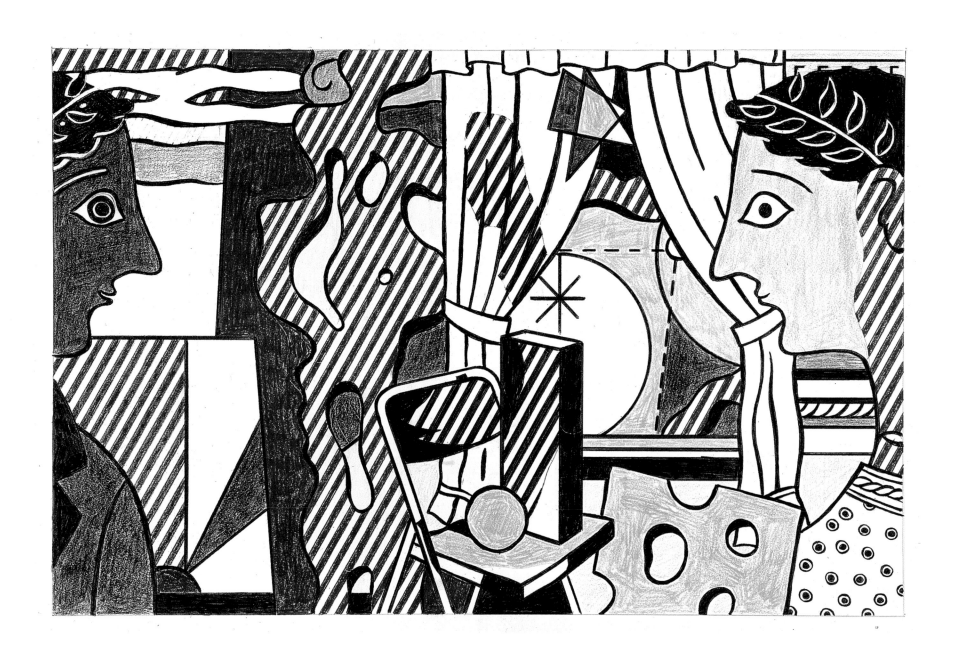

39

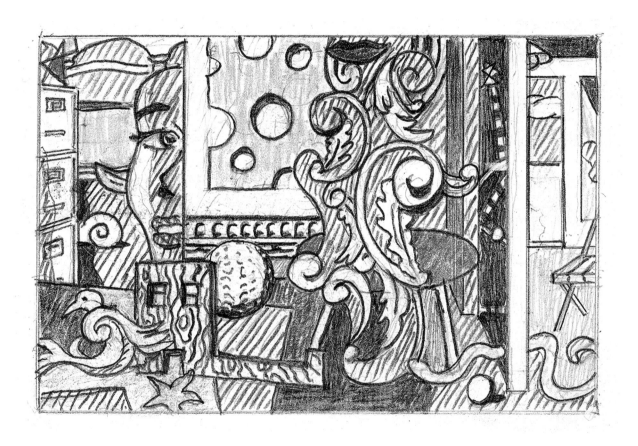

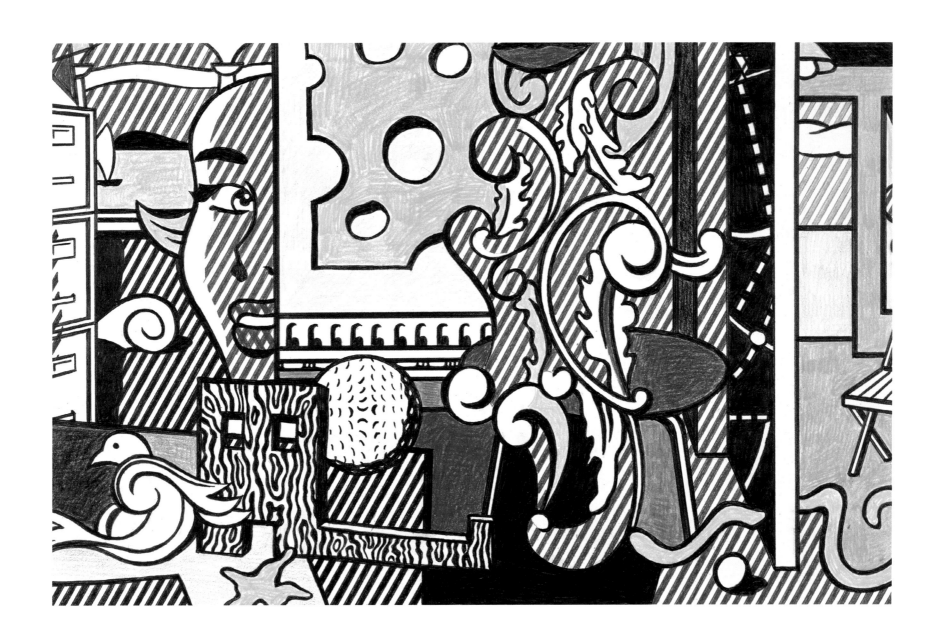

41

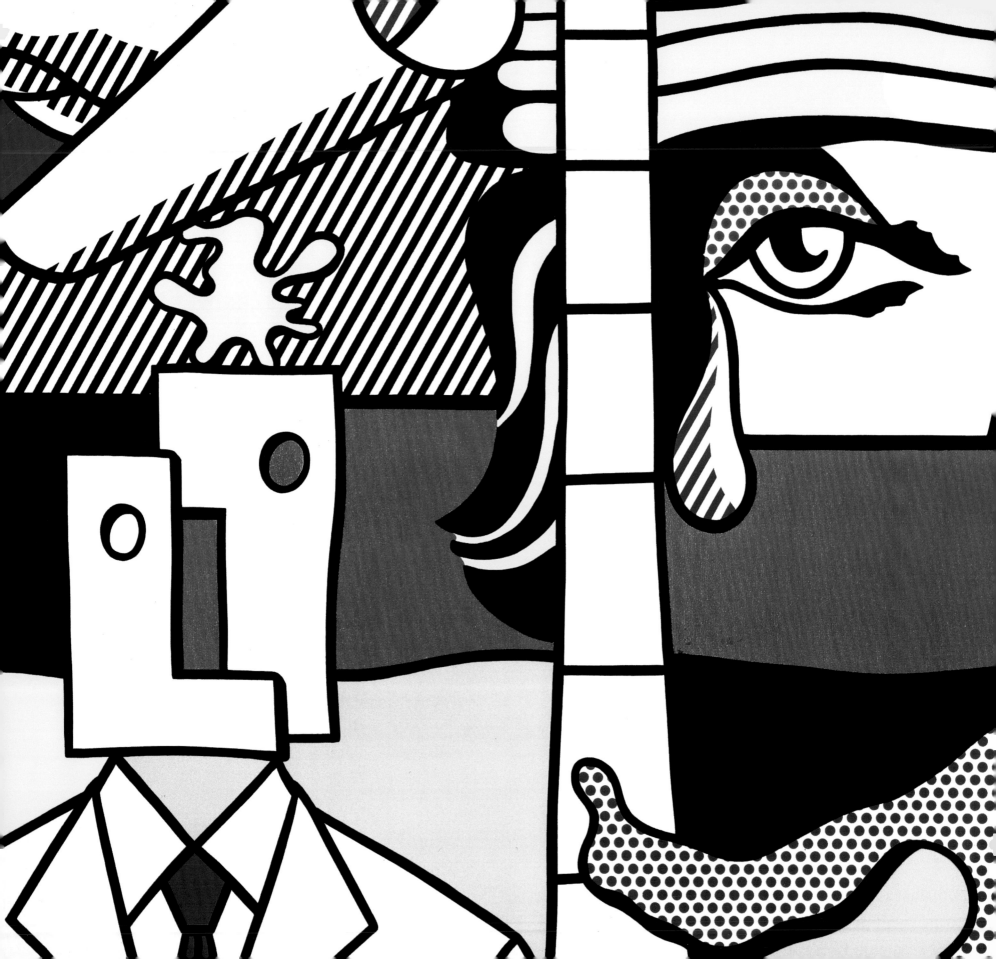

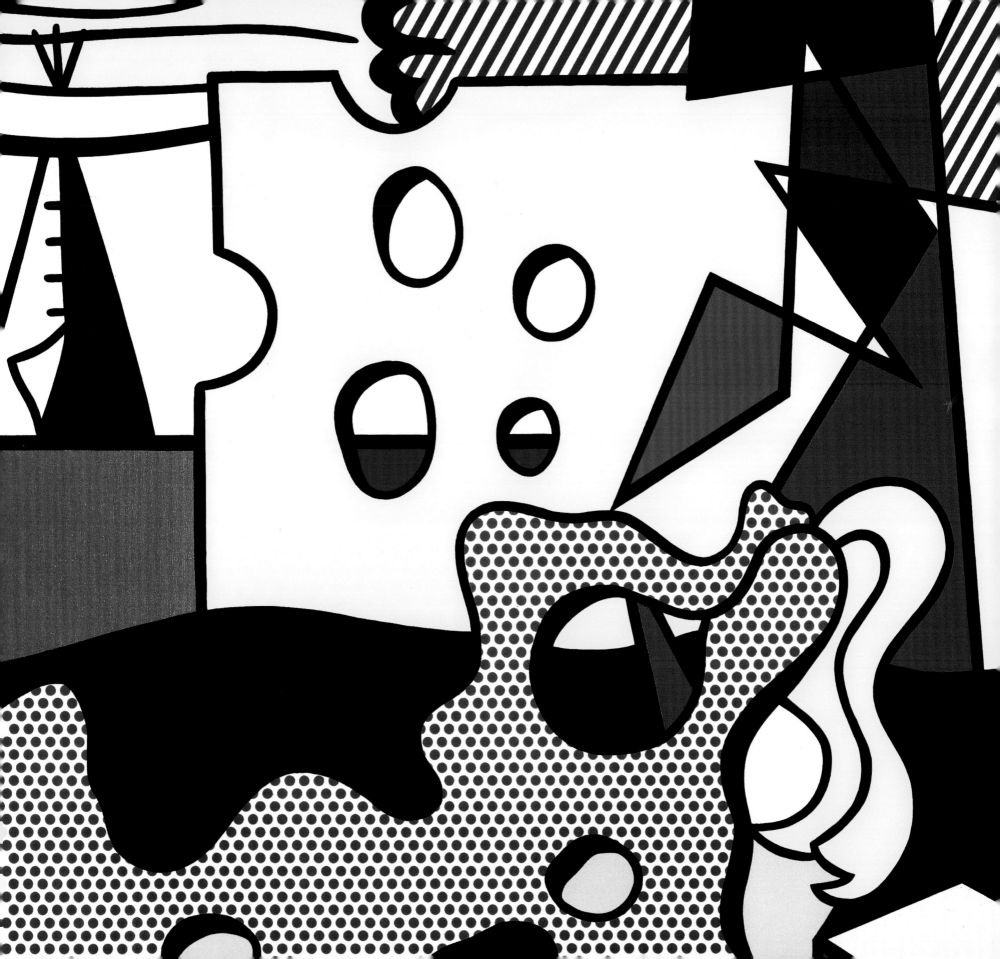

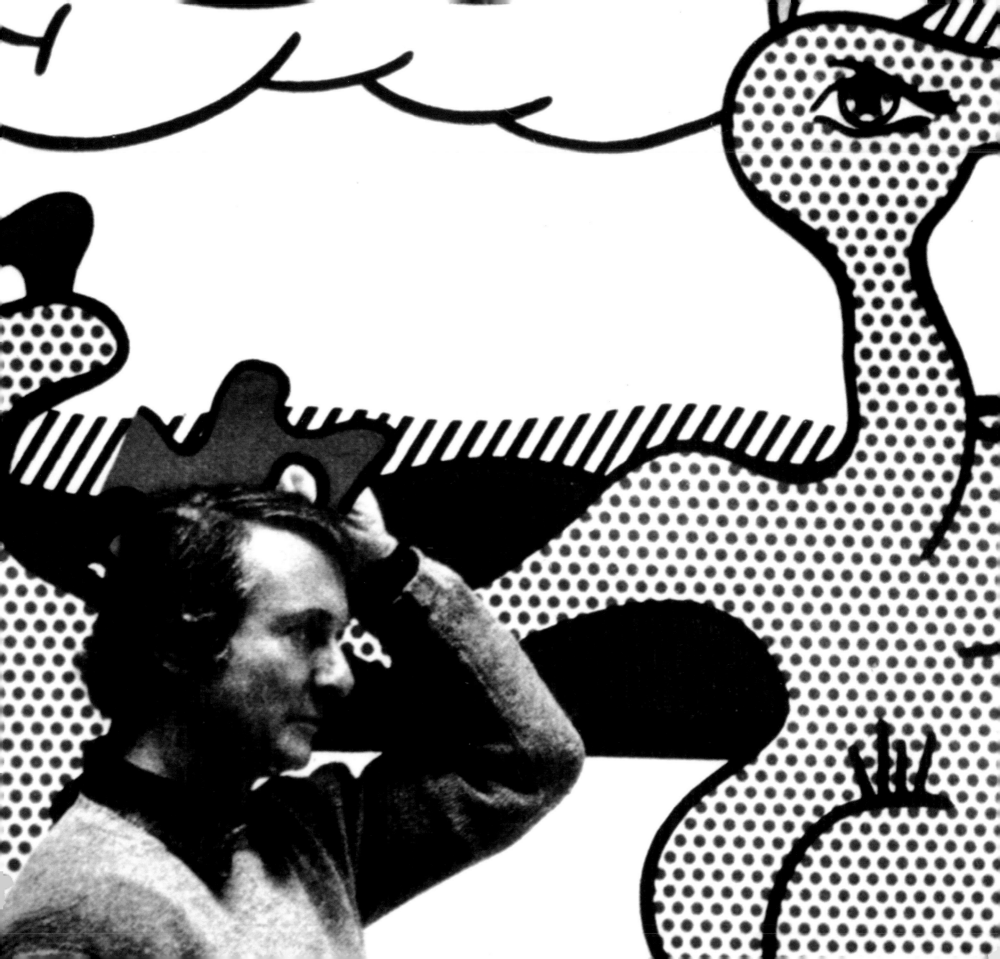

Searching for a worldwide audience in the 1930s, the Surrealists nowhere received more welcome than in the United States, with important exhibitions at the Wadsworth Atheneum in Hartford and the Museum of Modern Art in New York. The Julien Levy Gallery quickly became something of an unofficial New York headquarters. By the 1940s when Lichtenstein attended art school at Ohio State University (interrupted for military service from 1943-1946), Surrealism was widely acclaimed as the matrix style for contemporary American abstract art. Collector-dealer Peggy Guggenheim showcased European Surrealism while promoting such American artists as Pollock at her Art of this Century Gallery. *Abstract and Surrealist Art in America*, an exhibition surveying the exchange between European Surrealists and their American counterparts, was presented in 1944 at museums in Cincinnati, Denver, Seattle, Santa Barbara and San Francisco, in conjunction with the publication of a monograph of the same title by dealer Sidney Janis. Limiting its survey to American artists, the Art Institute of Chicago in 1947 presented *Abstract and Surrealist American Art*. It hardly comes as a surprise, therefore, that Lichtenstein's paintings, drawings and sculptures from the late 1940s and early 1950s are fundamentally Surrealist in spirit, teeming with biomorphic plants and creatures, often inhabiting dream-like nocturnal settings. Whether or not Lichtenstein was aware of them specifically, 1940s works by Duchamp and Dalí featured the same sort of commercial techniques and subjects that would become the basis for his Pop art in the early 1960s. Consider, for example, Duchamp's use of Ben Day dots, both for the catalogue cover for the April 1945 exhibition of works by Man Ray at the Julien Levy gallery (fig. 1) and for the dust jacket to Breton's *Young Cherry Trees Secured Against Hares*, 1946. In what would become Lichtenstein's influential strategy, each of these 1940s works consists of what is now called an "appropriated" image: a still from a Hackenschmied film and a souvenir photograph of Batholdi's Statue of Liberty. For his part, Dalí, whose

commercial illustrations were debunked by Greenberg as puerile in 1944, went so far as to publish his own proto-Pop newspaper (*Dalí News*) to handout at 1945 and 1947 gallery exhibitions.

As promised at the conclusion of *The Secret Life of Salvador Dalí*, 1942, the great Catalan artist intended henceforth to go beyond Surrealism and to base works on Old Master art. Dalí's decision coincided with a widespread tendency in the 1940s and 1950s to use pre-existing art images as the basis for new works. Such European Surrealists as de Chirico and Magritte frequently drew upon their own classic works. Beginning in 1954 Picasso based fifteen paintings on Delacroix's 1834 *Women of Algiers*. With his sophisticated grasp of authorship issues, Lichtenstein blithely copied one of these stylized Picassos for a 1963 Pop painting. Determined by 1961 to base his own compositions on pre-existing images of one sort or another, Lichtenstein often chose to replicate images that were themselves replications. Lichtenstein's 1962 paintings about Cézanne reproduce Erle Loran's diagrams of them included in his 1943 monograph, *Cézanne's Compositions*. Is there a similar connection between Lichtenstein's 1964 paintings after Mondrian and the image of a Mondrian composition made with patterns of dots and diagonal lines included in the 1957 book, *Dalí on Modern Art*? The "dopey" (to use one of Lichtenstein's favorite terms) dust jacket for this book (fig 2), with its overlapping reproductions of works by Picasso, Léger, Miró and Matisse, some propped up with Dalí crutches, amounts to a minor prototype for the complex composite Surrealist-theme paintings undertaken by Lichtenstein from 1977-79. But no Dalí image so directly prefigures Licthenstein's art as *The Sistine Madonna*, 1958, copied from Raphael's iconic altarpiece. Dalí's work features an overall texture of dots as part of the transcription of his other source image, the detail of an

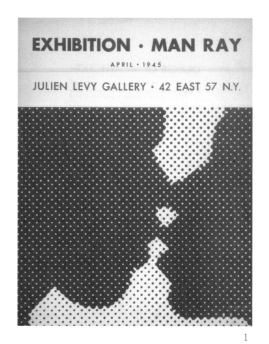

1

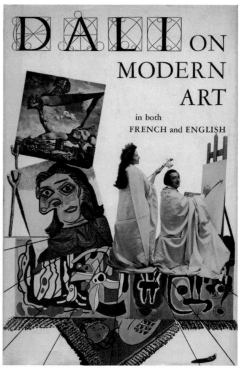

2

ear from a photograph published in *Paris Match*.

Except for their flagrant humor, of course, Lichtenstein's Pop art and even his 1977-79 works on Surrealist themes are antithetical to fundamental principles of Surrealism. Whereas classic Surrealist art strives for spontaneity with the use of automatist and chance techniques, Lichtenstein's images are strictly pre-meditated and meticulously rendered. Moreover the inevitably upbeat mood of Lichtenstein's images is far removed from the foreboding mood essential to even the sunniest Surrealist works. Even so, Lichtenstein's Pop art appealed to collectors with a special fascination for Surrealism. To take one example, the November 1979 auction of the Surrealism collection of painter William N. Copley included four works by Lichtenstein. Supposing Copley and Lichtenstein shared insights about classic twentieth-century works of art, was there any connection between Copley's interest in Magritte's sculptures based on details from his own paintings and Lichtenstein's conceptually similar sculptures, with few exceptions created beginning in 1977 as he turned his attention to Surrealist themes?

Arguably the most complex pictures Lichtenstein had attempted up until 1977, his Surrealist theme works should be understood as an ambitious response to the Whitney Museum of American Art's survey exhibition *Art About Art*, organized to investigate the widespread parody and appropriation of history of art icons by contemporary artists since the 1950s. Lichtenstein was the most extensively featured artist in this exhibition, with more than twenty works, including the Picasso-esque *Girl with Beach Ball II*, 1977 (plate 45; fig. 3 for the source). In the catalogue, this brand new work was reproduced in tandem with Lichtenstein's 1961 *Girl with Ball* (fig. 4) to emphasize the consistency and seriousness of the artist's ongoing meditations on images, whether from Pop culture or from museum culture,

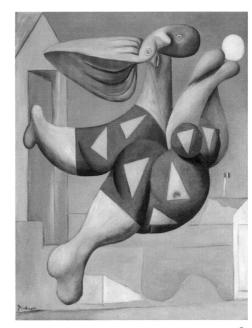

3

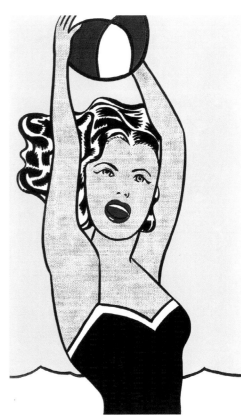

4

ever less distinguishable from one another after World War II.

As if in anticipation of the flood of Postmodernist writings after 1980 about reproductions and originality, the cover that Lichtenstein provided for the *Art About Art* exhibition catalogue (fig. 5) stresses his double (or multiple) awareness of his own present role as an artist conditioned by memories of earlier art by himself and others. The catalogue cover image is a reprise of Lichtenstein's own 1973 painting, *Stretcher Frame Revealed*, showing the removal from its stretcher of a canvas. This work, in turn, recalls Lichtenstein's 1968 paintings (one included in *Art About Art*) of the blank back of a painting with the stretcher bar frame and corner keys.

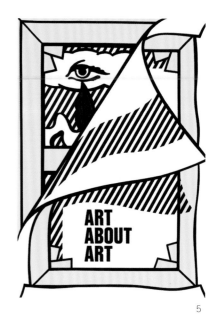

5

While Lichtenstein left the background blank for his 1973 *Stretcher Frame Revealed*, for the 1978 catalogue cover he indicated a second painting behind the one being removed, visible (both figuratively and literally) as the "source," the inspiring muse, the starting point for new picture making. As explained by a caption in the catalogue, the odd image of an eye poised on misaligned lips, which thus can be read as a teardrop, is a reference to Lichtenstein's *Crying Girl* paintings of 1963-64 (fig. 6). It goes without saying that these Pop paintings themselves make reference to famous teardrop images by Dalí and Man Ray (fig. 7). The notion of balancing one facial part on another to create a face is most explicit, however, in Magritte's 1937 *The White Race* parody of Picasso's 1920s beach paintings. Magritte later chose to isolate the figure in this work as a bronze sculpture (fig. 8). Bearing in mind the Whitney's mandate to specialize in American art, however, Lichtenstein fashioned the isolated facial details in keeping with iconic images by American expatriate artist, Man Ray. His *Object to be Destroyed* (1923/33/63), with its disembodied image of an eye mounted to the blade of a metronome, and *Observatory*

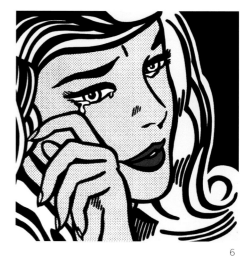

6

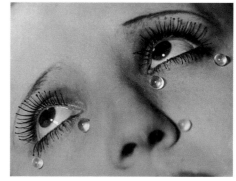

7

Time – The Lovers (1934), showing red lips floating in a sky like sunset clouds, supply the essential details for Lichtenstein's face. Like Joycean wordplay, the image reads this way and that. Thanks to the removal of the covering *Stretcher Frame* canvas with its stripe pattern shadows, the revelation of the muse in the background is a sort of unveiling, or a stripe/ strip tease. The misaligned lips and the mirage-like eye in the Whitney catalogue cover suggest someone peering out through a keyhole. What this fictional voyeur sees are little wood keys in the frame's corner whose function is to keep the canvas perfectly aligned from top to bottom and from side to side.

Eyes and the theme of looking are pervasive in Lichtenstein's Surrealist works. Take the portrait with the slice of Swiss cheese as a levitating head, referring both to Magritte paintings with objects masking faces (fig. 9) and to the familiar photographer's instruction to a model: "Say 'Cheese'." The two holes that show the same background stripes should seemingly be read as "eyes," leaving by process of elimination the third hole to be read as "lips," suggested by the curtain fold visible through the void. So the yellow, and thus blonde, head is cocked to the left. While Lichtenstein himself painted a wedge of Swiss cheese in 1962, the Swiss cheese slice image here indicates a blatantly Surrealist mindset, aware of the photograph of Swiss cheese used in 1942 by Duchamp for the cover of the *First Papers of Surrealism* (fig. 10) exhibition catalogue as well as the patterned paper cut-outs and the hole-ridden eroded stones or misshaped skulls so prevalent in Magritte and Dalí works beginning in the late 1920s.

Like a discarded mask, the Swiss cheese face appears again and again in Lichtenstein's Surrealist works, the way odd details like legs and garbage can covers appear repeatedly in Philip Guston's Surrealist-spirited figure

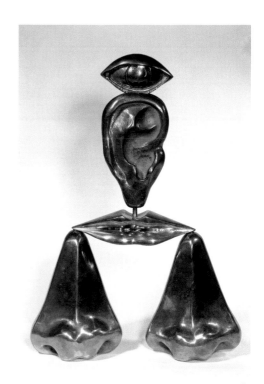

8

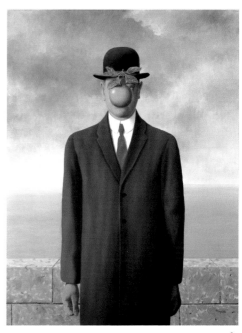

9

paintings of the 1970s. What to make of the Swiss cheese mask in *Nude on Beach* (plate 43), with its bather melted and sunburned like the misshapen figures in beach scenes by Picasso and Dalí from the mid 1920s or Henry Moore's bronze Reclining Figures of the 1930s with gaping body holes? Does the Swiss cheese signify the large blonde head of a watchful parent nearby? Or, possibly a yellow swimsuit, removed by the child with the toy shovel as an innocent act of sun worship?

Her skin dotted red the same way, an anatomically comparable nude dominates Lichtenstein's grand, allegorical *Cosmology* (plate 52), which includes the Swiss cheese mask cast off in the foreground. The upper part of her head is missing, as if she were to be regarded as a sister of the "headless" Surrealist women in Ernst's 1929 collage novel, *La Femme100 Têtes*. *Cosmology* and Lichtenstein's other large Surrealist compositions, with so many strangely conjoined details, overlapping one another without concern for spatial logic, simulate the puzzling cut and paste juxtapositions of collage and montage. As Lichtenstein's copious sketches and drawings receive more attention it should become increasingly clear how he often developed motifs in isolation, using shape, shading and pattern in as many different ways as possible. As he realized their possible interrelationships, Lichtenstein used his most basic drawings like collage elements to compile in more fully orchestrated compositions for eventual transposition to canvas. In works like *Cosmology* the disparate elements comprise mind-boggling treatises about the ways line and color can clarify and deceive. The role of drawing in the development of Lichtenstein's Surrealist works has a corollary in Picasso's Surrealism, with its extraordinarily inventive body of graphic work (fig. 11). Both the emphasis on shifting modes of representation and the wide-ranging cast of characters in Lichtenstein's Surrealist works – the

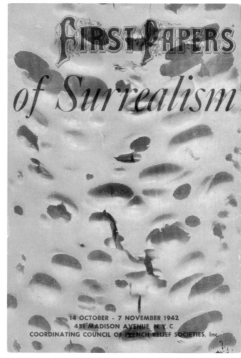

10

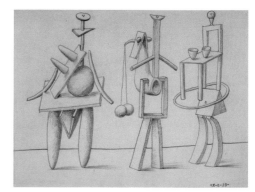

11

beach ball Venus, the laurel-wreathed Attic faces in profile, isolated and enlarged to appear like sculptured busts, the window, the curtains, the chair with toy props – such specific elements represented in a medley of graphic styles has its full equivalent in only one work of art of Surrealism's heyday. For graphic richness and imaginative scope Lichtenstein's primary prototype is Picasso's famous *Vollard Suite* (fig. 12), published from 1930-1937. Each of Lichtenstein's Surrealist compositions should be considered as a work of visual literature on par with the plates in Picasso's *Vollard Suite*. The Pop artist's late 1970s compositions are his most complex meditations on art about art about art, to make the mind's eye blink with Surreal insights.

12

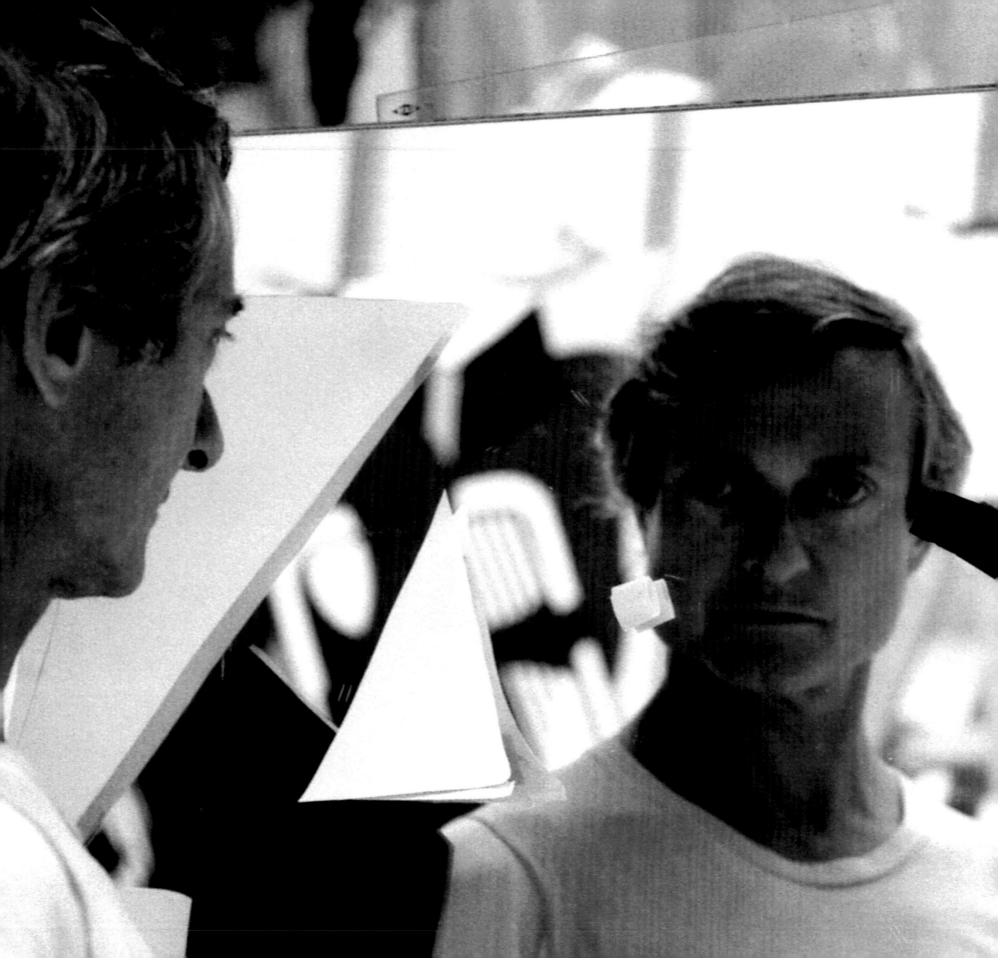

PAINTINGS

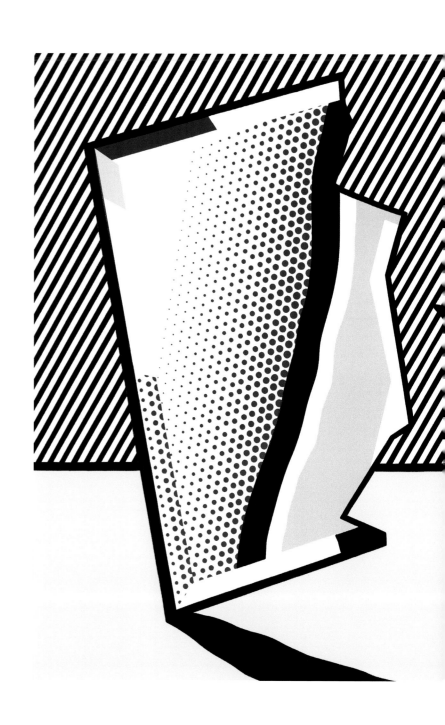

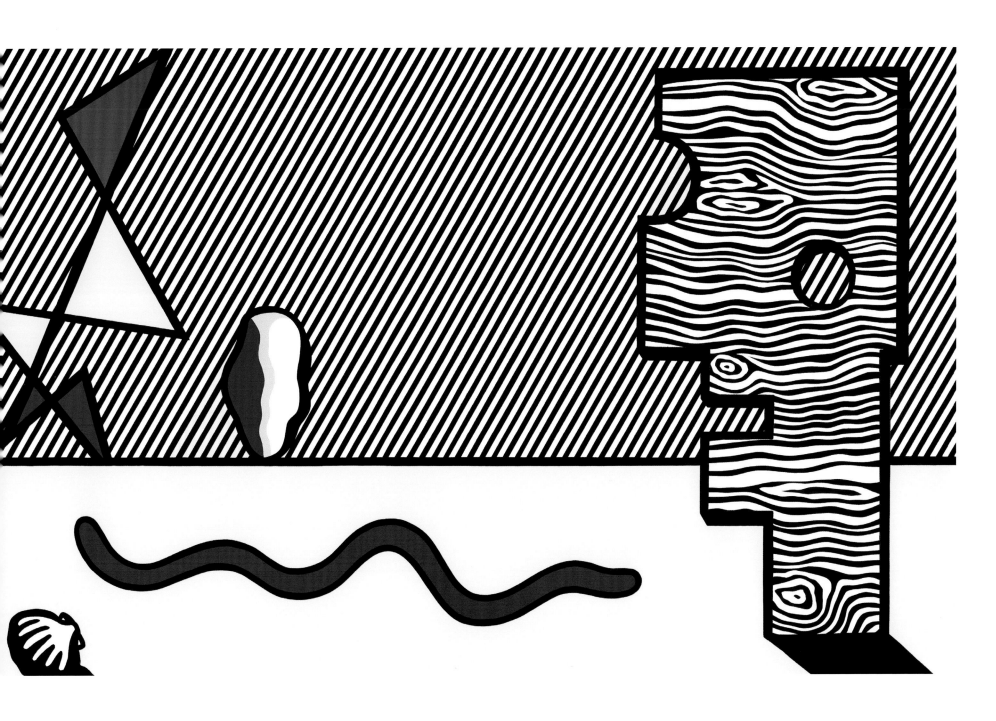

43 **NUDE ON BEACH** 1977

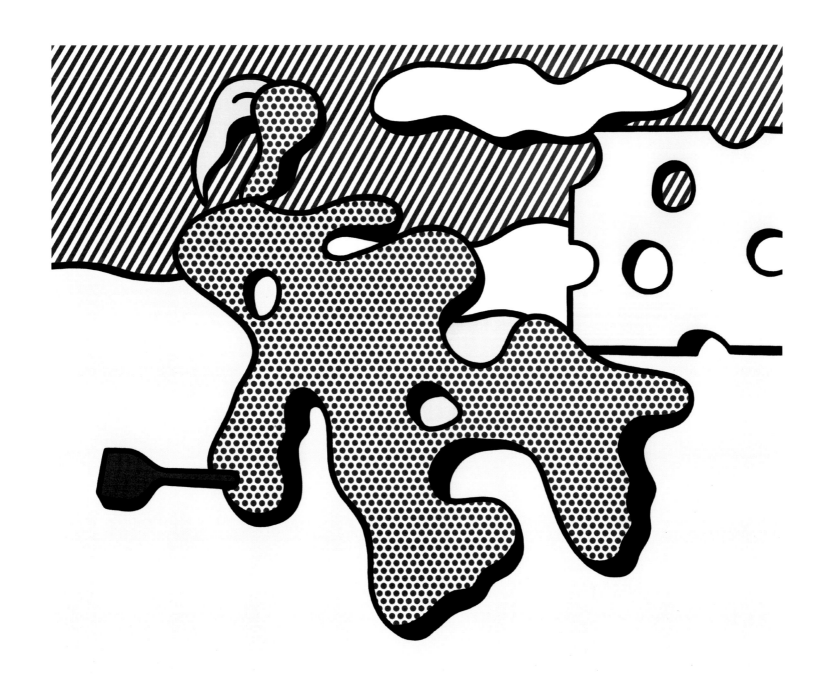

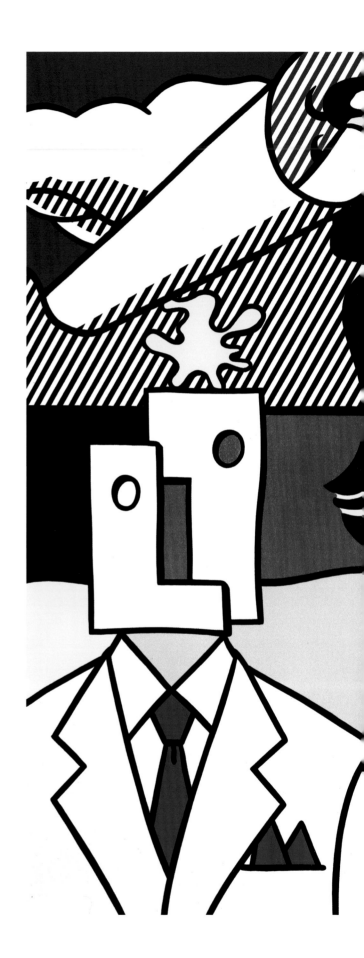

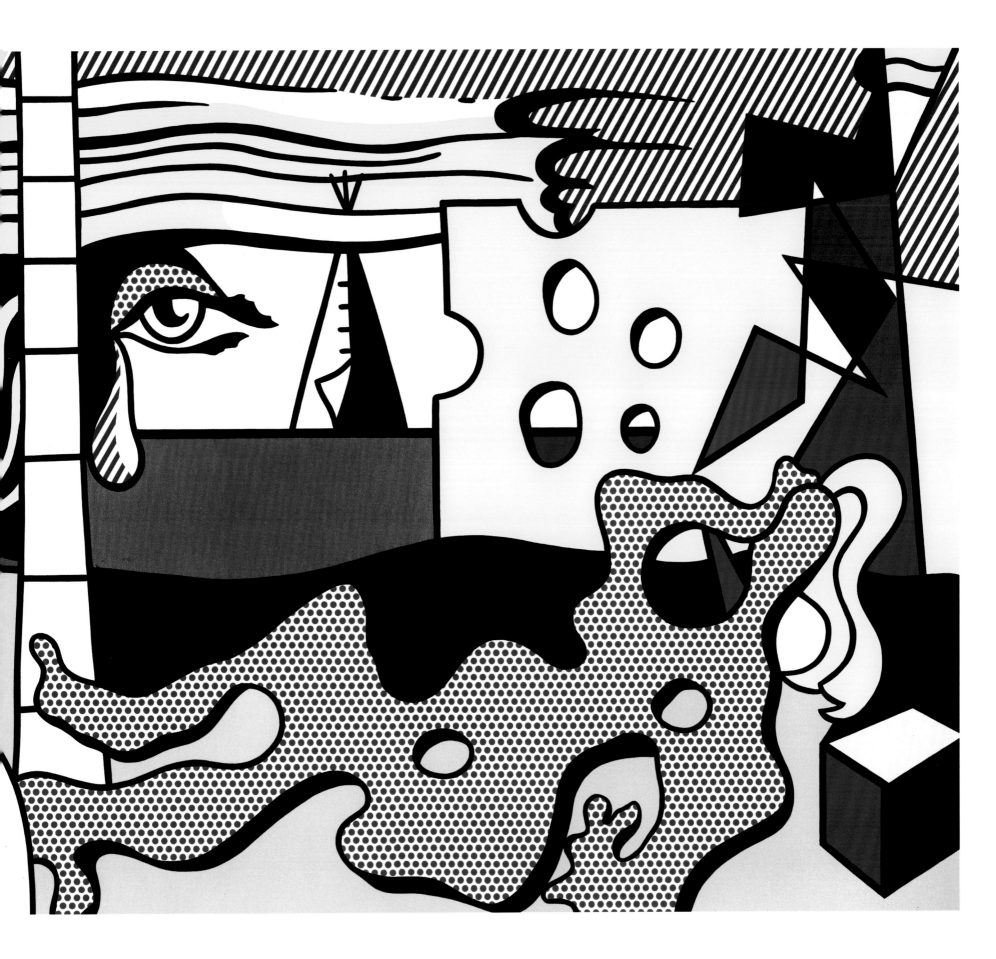

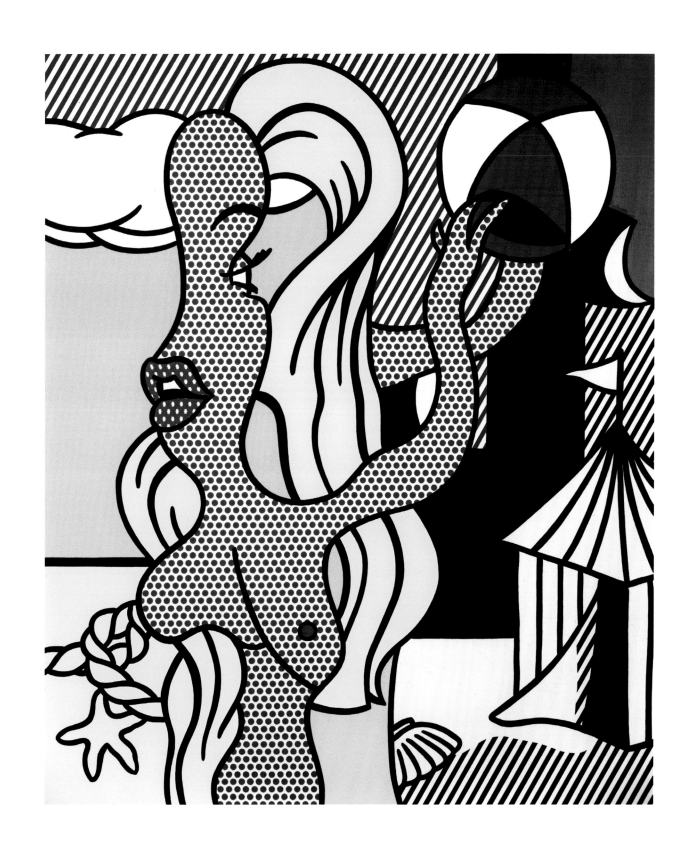

46 **FEMALE HEAD** 1977

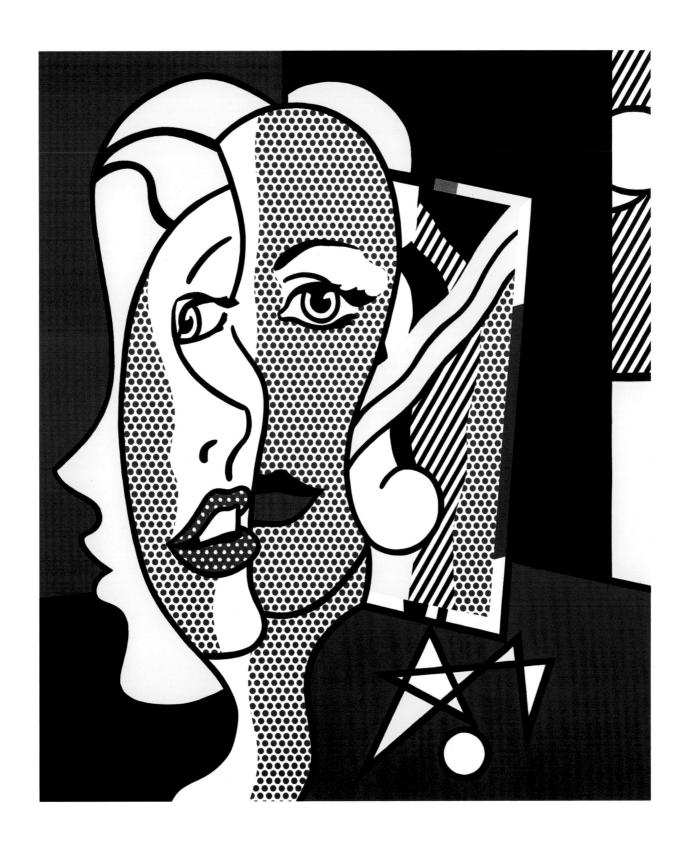

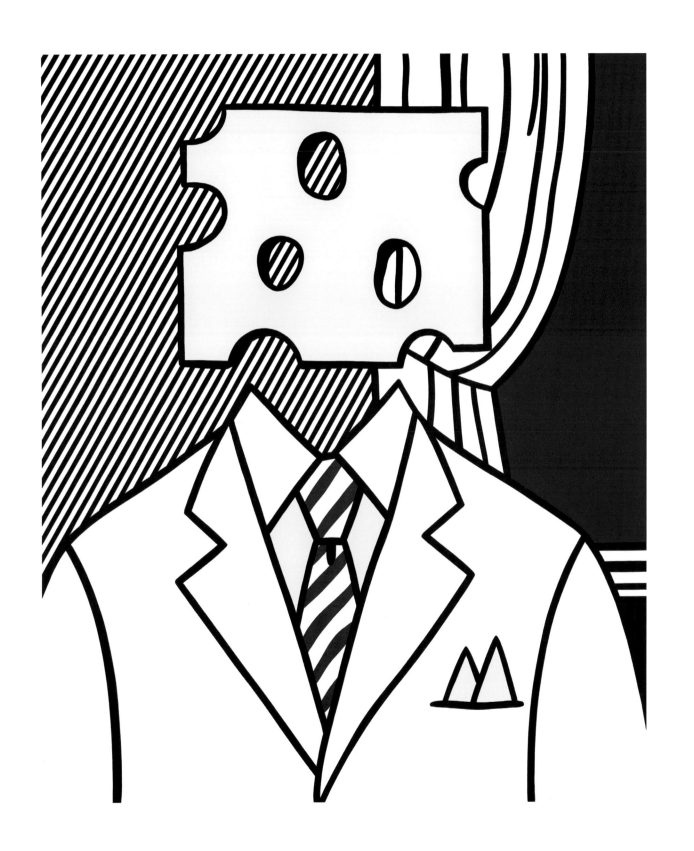

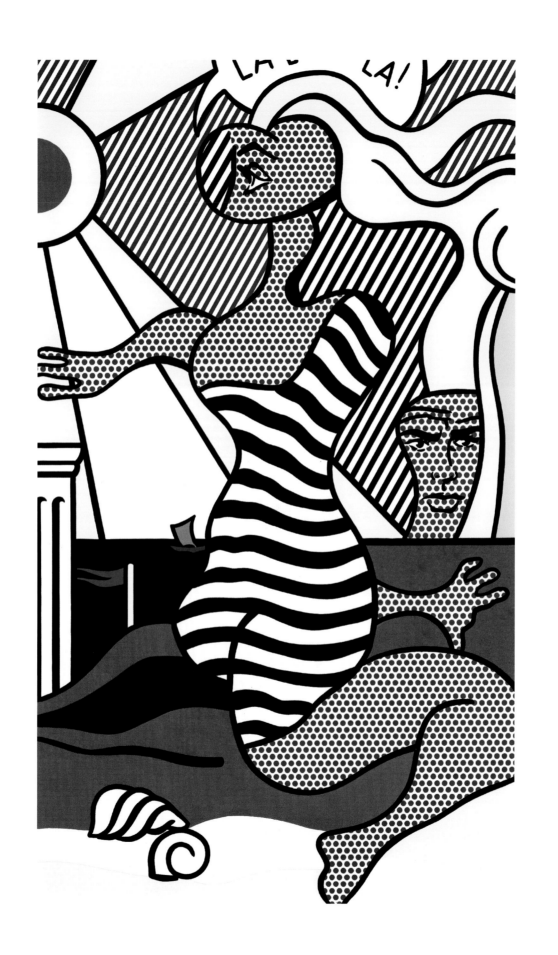

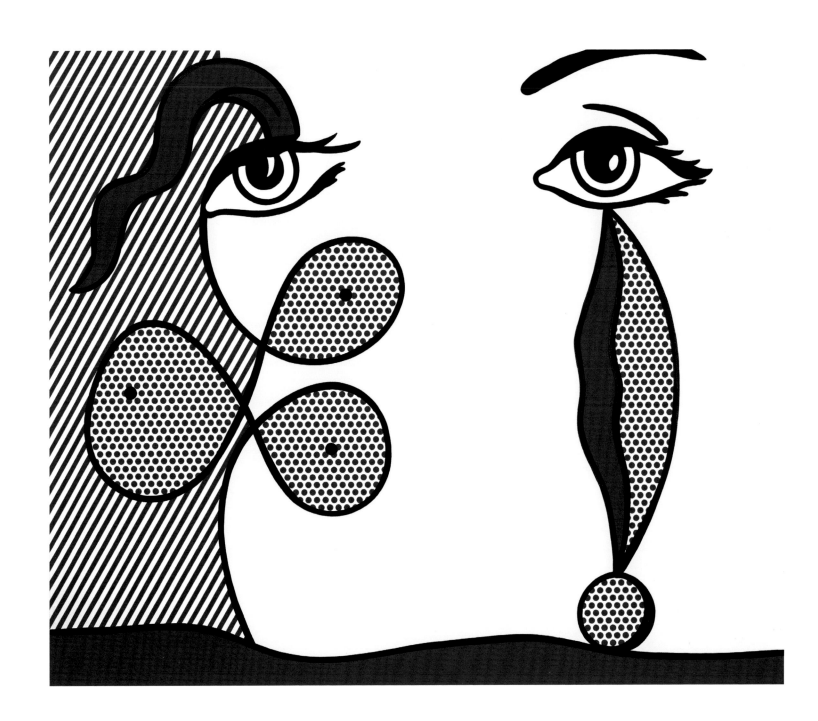

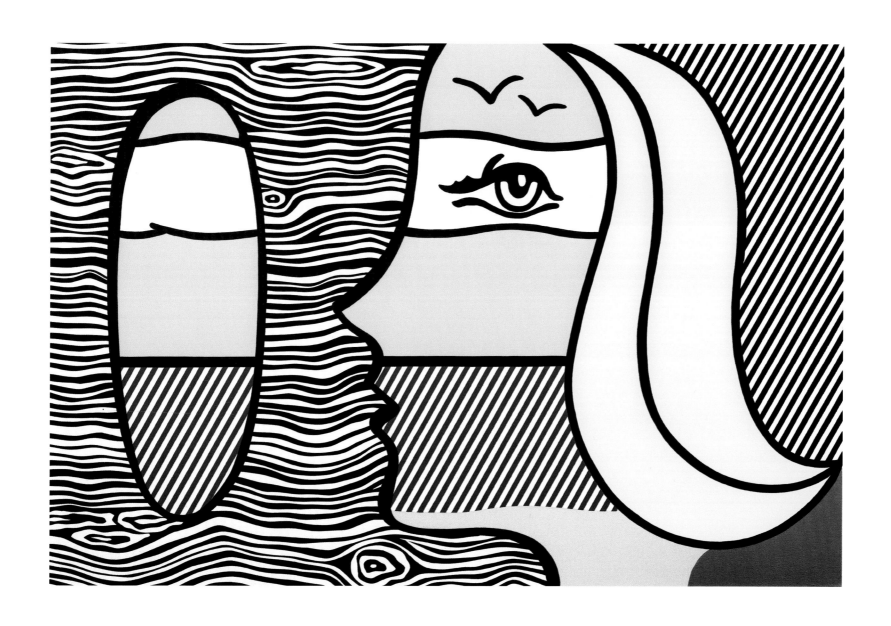

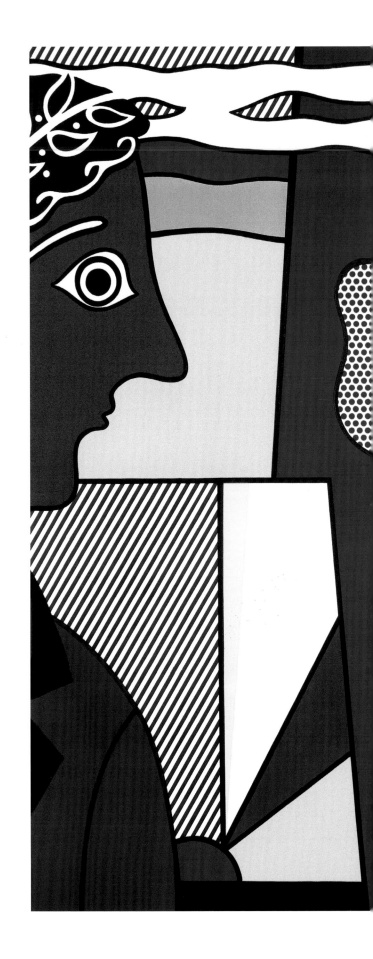

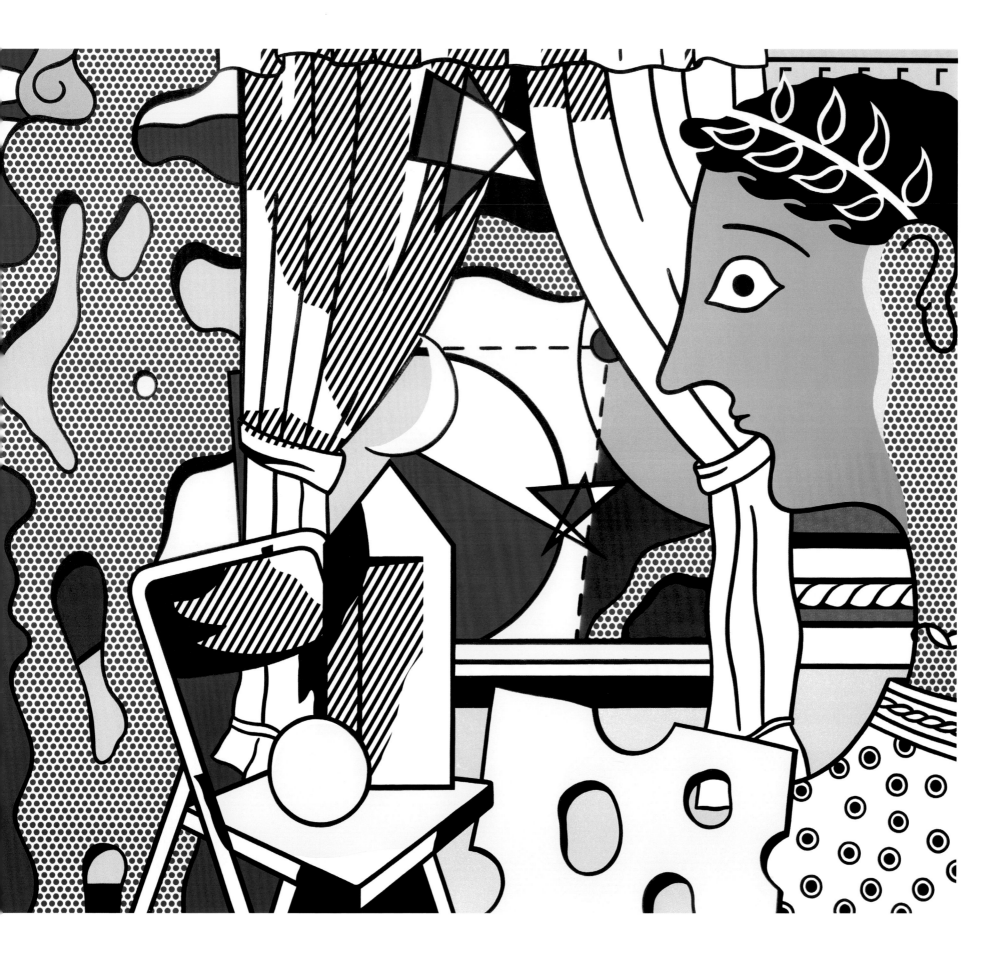

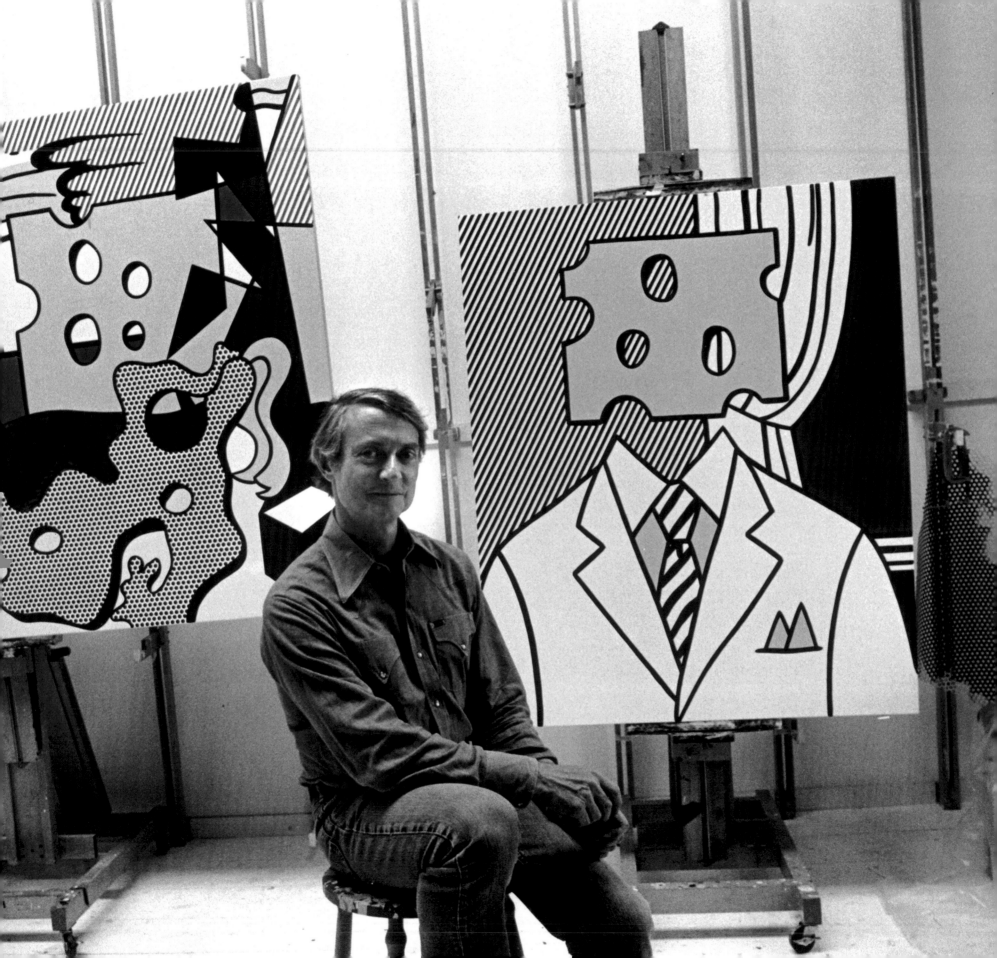

THE CONVERSATION: SELF PORTRAIT WITH CHEESE Frederic Tuten

The sardines were not forthcoming, not to be brought forth, the waiter announced. Plenty and various breeds of cheeses to be had; olives as well, hard ones, with little pimento eyes. Martinis, for sure. Young ones, smoking with cold. But the sardines were to remain on their shelf, entombed in their oily tins, not to see the light of day. Or any light, whatsoever.

"And the salmon? Are they running free, now?" I asked cautiously. Best to be cautious about the salmon, they are so sensitive to inquiry. Especially from bears and men with magic wands wading in cold streams, but there was no need for them to fear us, as we were far away, across from a museum, in a hotel garden, under a red umbrella, beneath a toothless sky.

The waiter was indifferent to the salmon, had no thoughts about them, he said, as they did not swim in the current menu. He was a fancy-talking waiter, who nursed us after we devoured the day devouring paintings. It was a strenuous life, if you were not built for it.

"I guess I'm not beautiful at all," she said. "But then again, who knows what that means these days. Do you?"

We had been talking, before the waiter arrived, about beauty, its properties, its various manifestations in art. Before I could answer, she asked: "Is a slice of cheese beautiful, a work of art?"

"It depends," I said, rather hastily, "on the color and texture and size, whether or not the surface is interrupted with perforations, and, of course, there's the factor of 'whatnot.'"

 "The 'whatnot' is crucial, of course," she said. "But what I mean is can a slice of cheese with all its 'whatnot' be considered a work of art, a slice of cheese deliberately sliced in a slicer or carved with a knife—not just some accidental hunk broken off a wheel, if you get my obvious point?"

"Well, if the cheese evokes your appetite, that would immediately exclude it from the category of pure art," I said, repeating some long forgotten formula. But I was soon filled with regret because I knew in my

heart that art could evoke a desire for love, for life, for food, for death—for all that all at once.

"I was once beautiful," she said. "I was the cheese and you my plate and individually and together we were beautiful. But I'm not beautiful now, alone or ensemble, right?"

"No, not beautiful," I said. "But still beautiful, in a desirable sort of way, if you know what I mean."

"So something that was beautiful in one way can become beautiful in another way?"

"Perhaps, in your case," I said, "but maybe not in any other. You may be the one exceptional and immutable and unique instance." I averred not too pontifically, not too diffidently, either, but with friendly authority.

"Well, you slipped out of that one," she said. "But you can't say that I'm especially clever or bright or talented at anything—or even with a body that makes men dream searing erotic dreams, a body that shatters memory and convulses reason."

"That's true," I said, with great purity, with great grace, a gliding salmon in a pristine river high in untracked mountains, in 1850 in America when the New World was still new in Albert Bierstadt's imagined golden West, a river falling into some giant frothing cascade arched by redwoods taller than cathedrals, higher than belief.

She thought for awhile, or seemed to be thinking. Then she said, as if having made a discovery: "And with no compensating charm to compensate."

"None very much," I said.

"What about money? Do I have money?" she asked her Martini with its drowned olive.

I waited, discreetly, for her to address the question to me.

"Well," she said, finally looking my way, "do I?"

"Some, but not enough to attract vivid interest."

"There you are!" she said. "I have nothing to recommend me. Not even in your eyes. And you say you love me?"

"I do."

"You say you do, but do you?"

"More than ever, more than never, more than mirrors, if you get my meaning."

"Wait! I'm not even any longer young."

"Of course not. Youth left you years ago. Fled you, I should say."

"So, you are leaving me, too, then?"

"Unlikely."

"Don't you have any principles? Any aesthetic? Any point of view, any taste, so to speak?"

"Let's change the subject," I hinted suavely. "Let's go for a walk. Let's go for a swim in some lake or river or creek. Someplace untracked and undiscovered, someplace where bears have never slept in winter, someplace mirror-smooth and unscratched, like a tabula rasa of the heart."

"What if I grow a beard?" she asked. "Would you still love me then, with a great black beard hanging down my chin?"

"Have I ever denounced your little moustache?" I asked, as if taking offense.

"Not to my face," she said. "Speaking of that, have you seen yours lately?"

"I can't find a mirror to reflect it," I said. "I look in a mirror and see a mirror."

She took me in very carefully, scientifically, so to speak, this way and that. Then, adjusting her eyeglasses on her bumpy nose, she said, "I look at you and do see a mirror, but not my reflection. What kind of mirror is that?"

"A paradoxical one," I said.

"What is the world coming to," she said, in a dreamy, melancholic, and finally, judgmental kind of way that implies that the world is coming to no good and will arrive there soon. To come to no good, meaning what, I wondered? To come to no conclusion I would wish for, I answered myself.

"Wait!" she said. "Does that mean you can't find a mirror to reflect your face or that no mirror reflects your face?"

"It means both," I said. "*Toot la der.*"

"I love when you speak French," she said. It makes me… it makes me… it makes me think."

"Makes you reflect, so to speak, in the Old World Cartesian way that bores me to death and makes dreamers yawn even in their deepest reverie?"

"In the Old World way," she said, paraphrasing me, "where mirrors, pools and all reflecting surfaces

have their mystery, which I wish I had more of, at least for myself, personally."

"Lots of reflecting surfaces in Cocteau's films," I noted, didactically, but cautiously so. "Though the films seem a bit stale now, as no one finds walking through smoky mirrors so mysterious or miraculous any longer. That's what the world is coming to, I suppose."

"I like best his film where the Beast is in love with the Beauty. Somewhat like our own story in reverse, nest pa?" she added with a cheery sadness.

"*Say vray*," I said.

"I'm very fond of you, anyway," she said. "Love you, even. Like a broken-winged seagull still longing to fly, still yearning to skim the waves and climb high above the spume."

"And into a wall," I said.

"I'm fond of your juxtapositions, cruel as they are," she said, "because I'm also fond of their true sources in such artists like Max Earnest and Salvador Dolly, in addition to artists I'm sure you've never dreamed of, dwelling as you do in the atmosphere of received and not too complex ideas."

"How insightful," I said, not too critically or too haughtily or too arrogantly or too snobbishly or too sarcastically or ironically, even. But with the dignity of a retired eagle on vacation, gliding above great smoggy, snow-capped cities.

"Wait! See! I'm not even especially insightful."

"Very perceptive," I noted compassionately, like the Buddha regarding the great snake finally swallowing the world.

"But you still love me?"

"*Sand sess.*"

"When you speak French," she said, "I think: Surrealism. Think of the irrational, the unconscious, the world of dreams, of Andre Breton's 1924 *Manifesto*, of the deliberate flight from reason and logic, of the abrogation of gravity, of all syntax, visual and linguistic, of Newtonian physics, of love on horizontal planes, of everything that makes the world the wonderful goofy place it is."

The waiter brought over a platter of sliced eyeballs, a gift of the house, in lieu of the sardines, he said, and then he said again. We were not sure whether to salt or pepper them or salt and pepper them or to

add a drop of lemon, but then, the world was wide with implications and the evening still filled with vacant empty hours ahead.

"You neither salt nor pepper them," he said as if reading our minds. Indeed, he had read our minds, being the perfect waiter, the waiter of one's dreams.

"They go well with fresh tears, not too many, however, and tears not born from sadness or welled up from existential chagrin or worldly disappointments," he advised.

"There is something rare about these eyes," she asserted, timidly, poking at the heap with her fork, the salad one, shaped like Neptune's trident.

I agreed, these were delicate, translucent, not like the thick sheep's eyes I once ate in the Atlas mountains, where they were served to me as a delicacy greater than salt gleaned from the mist of dreams.

"Of course," the waiter said. "I was sure you would notice their rarity, each eye plucked from the forehead of a baby Cyclops, so hard to find these days of Homeric disenchantment. I suspected from the first moment that you both had qualities of discernment," the waiter said. "Exceptional," he continued, "in the perception department—abstract yet rooted in things or thingness."

"Quiddity," she said, the more precise word. "Indicating the essential nature of things in existence."

"There are no essential natures, as all is mutable and transformative, except God," he said, giving to an ant wandering from his red troop a warning flick of his belt.

This is a fine and novelistic close of the day, I thought, the evening blending the gastronomic and the philosophical. Soon, memories real and imagined, adventures and journeys in the same vein were sure to follow.

"Let's leave," I commanded suggestively. "There is too much active activity here, too much discourse, one wayward ant too many."

It wasn't the ant, actually, but the telescope he was carrying on his shoulders that had disconcerted me. A tiny telescope, of course, midget sized, to suit an ant's ambition, one broader than mine, I was sure, because mine had winnowed down to sitting in a garden by a vast museum, while the ant's scope was vagabond and, considering the heavy instrument he suffered himself to carry, filled with celestial curiosity. For some while now, I noticed, I was going flat, like a white silhouette one slips under the door or between

the pages of a book.

The waiter presented our chit, which I signed with a toothpick prick of blood, as evidence of the gratitude for the exquisite service, for the gift of the eyeballs, which were already melting into a gelatinous little mountain on the plate. Like the mountain where once I lived in a cave, the home of a family of black bears escaped from a circus.

"Have I ever told you about my time in a bear cave?" I asked her absentmindedly, my mind being absent from the concern of whether or not she had ever heard me tell my story, so concerned was I, at the moment, with what finally had ever become of those bears, who had smelled so richly of dark Belgium chocolate.

"'Art must be convulsive or nothing at all,'" she said. "Is your story convulsive?"

"I'm not sure," I said obliquely, "but I know it bears telling. Or more truthfully, I can't bear not to tell it."

"Ha! Ha!" she whispered, like a mouse at vespers. "Well, then, I won't bait you any longer: Begin," she said expressively but without much feeling. And so I began from the beginning.

"They had deserted the circus, these bears, though, since they had not voluntarily joined, I can hardly say they had deserted it; had fled from it, I should say."

"Wait! Is this just another momma, papa and baby bear story, with bowls of steaming porridge?" she asked, interruptedly, inopportunely, impolitely, along with several other words beginning with "I," I thought.

Ignoring the intrusion, I recommenced: "They had been leading a happy beach life, so to speak, deck chairs, large umbrellas, icy waters in rapid rivers falling from mountains, where they lived in bucolic, familial isolation, in a commodious cave, carpeted with pine boughs and delicious downy bark, when they were plucked from their steady bliss by a band of circus slavers, who trucked them to a small city on the Western coast. Where they were trained, under methods that included electric shocks and beatings with a hickory stick, to ride tricycles, and to walk, upright and daintily, holding children's parasols aloft; to walk to and fro on tight wires high above flaming walls of fire."

"For some years, they endured all, restraints, beatings, hunger for their customary springtime salmon freshly pawed from the stream, endured the stink of stale hay and piss-soaked sawdust, of tight cages and tighter costumes, designed to make them resemble a family of humans, with pants and dresses and pork

pie hats and suburban manners."

"But nothing, not the dull, mealy meals, not the punishments for disciplinary infractions, not the stupid clothes, the crushing cages, nothing merited their displeasure as did the routine of their acts. Boredom grand, soporific and dull: the tricycle ride, round and round; the tight wire walk, back and forth and forth and back; the bear family at High Tea with an uninspired midget lady dressed as Goldilocks, blond mop of a wig trailing over her face. 'Help us!' they cried. But there was no one to help them: the lions, elephants, the seals, the chimps, each had his and her own universe of problems, performance wise, and otherwise."

"Oh!" she said, in a tone expressing sadness. Then, brushing a pear-sized tear from her cheek, she added, "What a trite story."

"There is no pleasing you," I said, "nothing in fact or fiction will do, I suppose."

"Your head pleases me, or the mirror it has become," she said, "it pleases my eyes, because, happily, as you were telling your story, the mirror has come to include me, while leaving out the rest of the world."

"Did you notice that!" I said, suddenly moved to the legendary border of desire.

"Did you think I would be so obtuse, so blind? Though I must admit my eyes no longer have that brilliant sparkle and diamond gleam of yore?"

"Does this mean I may continue my story?" I asked, eagerly waiting for her answer, but knowing beforehand her reply. But before she could answer, I pointed to the sky, indicating the sudden appearance of herring clouds. Swimming, they were, in graceful little schools, unlike the cumulous clouds, which just drift along like stupid, puffy blimps, relying on their mass, as did the biographer of skies, Tiepolo, for dramatic effect.

"Related to the sardines," I instructed, having them on my mind after seeing that day, *Burial of the Sardine*, Goya's painting of ecstatic revelers at their festival celebrating the internment of that little fish, making me want to see some, sleeping in rows in their oily tin coffin. Thinking, also, that I would bury a tin or two and resurrect them as little oily paintings.

"Being in the same fishy family herrings are," I continued. Of course, all the meteorological info was a rhetorical trick of suspense, to keep her hungry for the continuation of my story. I had many such tricks up my sleeve and in several locations elsewhere, to keep her on the edge, so to speak and so to speak.

"Darling," she said, "I think I've heard enough of this wonderful tale for the day—and the evening, too. If you don't mind."

Sometimes, I have noticed, a person has to be in the mood to be tricked. Or needs a heavier grade of oil. So I tried again.

"Actually, it would hurt my feelings not to continue," I said, pointing this time not to the sky, but to my heart or rather to the general area under which it was invisibly doing its work.

She leaned back in her chair, a hank of blond hair falling over her face like a golden tail over a dry bone. A dry white bone with one eye that saw through mirrors and intentions. Leaned back, as if to say, continue if you must but don't mind if every so often I gaze up at the sky to marvel at the herrings in their thin sea. I took the hint gracefully—manfully, I suspect they would have said in olden times—and I braved my way ahead.

"They were very unhappily bored those bears, and, to make the story short, one night they escaped the cages and the circus itself." The details of their escapade I held back for another time, another garden, another city—perhaps for another woman, one more easily aroused by tales of devil-dare and daring-do.

"Fled the towns and villages and the sandy coast and straight up into the mountains, where they soon found a new cave for their home, one as deep and cozy as their last and in even a more remote, desperate region, shunned by campers and other thrill seekers. There they settled down and began their new, free life. Just the three, except for me, who, lost in the mountains and starving and desolate, was amazed, when, just as I was ready to give up the flesh and let my soul decide its own way, I stumbled upon the family of bears drunk on berries and honey."

"In a little clearing by a rapid stream they were, half awake and half in the lazy drowse of their inebriation, and belly up in the sun filtering gently through the pine branches. They quickly discerned that I was not a hunter or bear-catcher, that I was a solitary, lost being, myself wary of my own kind—humans, that is—and happy to have run into them and not a tribe of dancing, mouth-frothing, green snakes, so abundant in those wild regions."

"They took me in, literally. Giving me a corner of their cave and a bed of pine needles and they let me share their food—the water I drew myself from the cold so cold and so clear stream. They smelled of

chocolate, as I remarked earlier, smelled like giant chocolate bears you would wish to take a bite of. So comforting their aroma, at night, when we all went to sleep, when I wanted something familiar of home to reassure me that I myself had not become a bear, a wild animal, who had once been trained to perform stunts, to entertain."

"Slowly, I learned that they could speak. Not loquaciously, not fluently, not with a broad vocabulary, not with nuance, but well enough to say what they wanted to say and to send their thoughts to me across the dark cave. Ursula Minor, as I called the baby bear, was the least articulate and perhaps the most mature in thought. Ursula Major, the Papa, spoke most directly, but without subtlety. Ursula Mater, was the most rounded in speech and mind, and the most attractive of the three, with a silver streak running down her furry cheek."

"Theirs was a happy home. The salmon ran like water. Berries dropped into their mouths, the honey was inexhaustible and the bees careless. They liked each other, admired each other's integrity, were glad to be a family. But they were growing bored, growingly despondent, sometimes even glum. My unexpected appearance gave the lift that novelty gives, but after a month of me, the novelty wore thin, like a holiday alone in bed."

"'Bored,' Ursula Mater said, because in some sense, they were no longer the same bears as before they joined the circus."

"'Joined?' I asked."

"Of course, they had been abducted, kidnapped, hauled off. But they had picked up the expression 'joined the circus,' meaning to trade a staid world for an exciting one, and the term seemed to befit the mood they currently were in."

"'How much salmon can we eat until we are gorged and sick of salmon?' Ursula Mater, asked. 'We hardly have to dip our paws in the stream and there they are, thick, fresh, juicy, ready to slide into the mouth. Ditto with the berries and the honey.'"

"'And then, what?' Ursula Major, added. 'We lay about, roll about, lounge about all day then take a dip in the hottest part of the afternoon and then laze about again in the shade.'"

"'That's a bear's life, Papa,' Ursula Minor said. 'Except for the endless sleeping in winter.'"

"'A little variety, would help,' Papa said, 'a little something extra to do.'"

"'Something more imaginative,' Ursula Mater, said, wistfully."

"'Look!' I proposed. 'What about a spirited weekly seminar on the history of human kind?'"

"And its art, too?" she asked, trying to catch the waiter's good eye, which seemed to be floating about thoughtlessly.

"Of course," I said, "What don't you take me for?"

"Wouldn't that have been hard, without the visuals?"

"I thought I would make drawings on the cave walls, a history of Western art on stone."

"What a splendid audience for your Eurocentricities," she said, fetchingly but with a certain languor.

"The point is that they liked the idea and we set aside Tuesday afternoons for our little salon."

"Tuesdays are very good for laundering seminars," she said.

"To interest them, I started drawing pictures of famous paintings with a cave in them, like Giotto's Saint Francis de Assisi standing before his."

"Before his what?" she asked.

"Before his birds and bears came and stole his acorns, trying his sainthood," I said. Then I added, graciously, "Have you ever seen the bubbles cheese make under a blowtorch?"

She gave out a polite yawn, like a whale at dawn. "Those lucky bears," she said, "all that history delivered right to their door."

"And it was free," I said, "and loads of fun, and they were very grateful. But after two weeks, Ursula Mater took me aside."

"'Look,' she said, 'no offence to you, but we've made a decision to leave here.'"

"I was immediately sad for the loss for my friends, but then I grew frightened of my prospects, myself alone in the cave with no way to feed myself, and without means of finding my way back to—dare I say?—civilization. To wander in the mountains, to starve, to be eaten by dancing, frothing snakes!"

"'To go where?' I asked, 'Another mountain, another cave?'"

"'Back to the circus,' she said."

"'To the old slavery and abuse, back to its routine and dreary monotony?' I asked, without irony,

without anything but chagrin and the sense that my world had just darkened, shades darker than our cave at night—because even at night, the moon light sometimes carpeted our entrance and coated the rough walls a cool silver."

"The strange thing, Ursula Mater said, was that they missed dressing up—Ursula Major liked his straw boater and pork pie hat, his green bow tie and seer sucker suit with the red sash, she liked her yellow apron and matching bonnet—Ursula Minor missed his baseball cap and catcher's mitt the size of a cherry pie. They all missed the crowds and the applause, the giant tent and the loud music. They also missed showing up the lions, who had really little to do by way of performance, theirs being the job of self-negation, of cowering and leaping through hoops, of being submissive, of showing how all their power could crumble at the crack of a whip."

"They even missed their old acts, she continued—the tight wire, the piano solos, the teas with the midget and sometimes drunk goldilocks—not to forget the applause they brought."

"'You've already mentioned that,' I said."

"Not to return to the old routines, not to the old slavery, not entirely: they had a plan."

"Which was?" she asked, her voice and in the way she hovered over yet another martini, showing no intense interest in getting an answer. The herrings, schools and all, had beaten a retreat, so not there was little of novelty left in the sky for me to bring to her attention—and from that diversion, lead her back to my story.

What a failure, I thought, with a non-reflecting mirror for a head, with a head filled with odd tales of little compelling power. For all the art history lectures—with visuals—for all my pantomimes and stories and games, for all my telling them of human history, of philosophy from ancient times, when even blind men sat in little shaded groves and discussed their love for beauty, I could not even keep content the bears in their den.

"Where have I mislaid my life, dear?" I asked.

"I'm sure I don't know," she answered, with an olive between her teeth, like a little cannon ball ready to be fired.

"It seems I have left it behind me somewhere," I said, looking about the empty garden, as if it had

gone to another, less demanding table.

"Why don't you ask around," she said, "someone's bound to have found it."

The waiter appeared in his jodhpurs and rose ballet shoes; he was bent low, looking for wayward ants, his long belt trailing along the gravel.

"I think I'll order a dozen martinis," I said, "and see how many I can drink before they get warm."

"That's a wonderful idea," she said. "We can save the leftovers for breakfast tomorrow. Have them with the sardines."

"Better with salmon," I said, "raw, cold from the stream and still quivering."

"You should know," she said, respectfully.

And with that settled and my authority restored, I continued my story, disregarding my audience's indifference for the sake of its completion—for the selfish sake of my hearing again all that happened.

"'The ringmaster was not a stupid man,' Ursula Mater said. Nor, too, the bear trainer. Not stupid, but their view was limited by all the years of the same bear acts performed with little variation the world over. It was the family's idea to add some new material to their show, which they would create, and blend it with the known and traditional—the tight wire, the tea party etc."

"'Talking bears!' I shouted. 'That's what they will see and hear. Forget the acts, the routines, the stunts: talking bears!—it will make the circus billons and you won't have a say in anything you want to do.'"

"'Talking is not included,' she said, 'not part of the deal.'"

"'Your deal, not theirs,' I said. 'And even if they agree, when the word gets out, the scientists will come and put you in cages more horrible than you have ever known in the circus. And they will do things to you that no bear can imagine.'"

"They had vowed, should their wishes not be met, to end their lives What would the circus have gained then?"

"'Kill yourselves?' Impossible, I thought. 'With what means would you be able to effect such a thing?' I asked, smugly."

"She gave me a long bear look, suggestive of sympathy for me and pity for my blindness."

"'With our imagination, of course,' she said."

"'But why have it come to that?' I asked, in a chastened way—because I felt chastened, humbled by a bear—why when they could stay here in their cave and live so pleasantly, live to see Ursula Minor have a family with a brood of cubs for them to fuss over in a grandparenty way?"

"'No,' she said. They had decided."

"Then I hit on a brilliant idea, I thought."

"'Why not create your new acts and perform them for me,' I suggested. Ursula Mater paused, excused herself and went into conference with the others, returning to say that—with all respect to me—an audience of one was almost like none at all. Leaving apart the costumes and the music and the jealous lions."

"'And the applause,' I reminded."

"'There's that,' she said. 'Anyway, you would have grown bored watching us after awhile, and then we'd all be in the same place but older.'"

"I saw the wisdom in that, I said. But I was sad, nevertheless."

"The strange thing was that I was happy in that cave. A fat candle or two for the night would have enlivened the atmosphere, but I had grown used to the dark and to the wispy sighs and meaty snores of the bears at sleep."

"We finally left, surviving many dull adventures along the way, many near escapes from bands of dancing snakes, but we eventually reached the outskirts of the town where the circus was quartered. I was the bears' emissary and delivered to the incredulous ringmaster the family's desires and terms for their return, to which he agreed to before I brought him to their hiding place in a stand of trees behind a newly built shopping mall abutting a vast car-filled, asphalt lot."

"We said our farewells. How far are the words of goodbye compared to our feelings of loss in leaving those we love, but never as far as when you say farewell to bears, their chocolate aroma already vanishing into the vanilla landscape of tires and cars and mall."

Now it was night and little strings of friendly lights encircled the garden walls, keeping the darkness on the poorer side of the street, so to speak. Soon it would be time for an early dinner, and afterward a little stroll for digestion's sake. Then to bed in one of the upper suites, facing the museum, where we would visit

again in the morning after breakfast, when perhaps the sardines would at last appear.

We intended to eat lightly, as it was hot, even in the privileged enclave of the garden, where nothing of man or nature should have been allowed to discomfort us. What is the point of luxury, after all, if not to shield you from the irritations suffered by the many?

I ordered the salmon again, thinking one might emerge under the shelter of night, but this new waiter also shared his predecessor's principles in not negotiating what was not inscribed on the menu. I had asked again, thinking that just to say the word "salmon" might magically conjure us up a cool breeze drawn from my old bear cave, where so many of that fish had floundered about on the cold stone floor waiting to die.

We ate in silence, silently. All our conversation seemed spent. I had spent it. The dishes cleared, the waiter returned and asked me, "Coffee, cheese?"

"Coffee," I said.

"And the cheese?"

"She'll have the same," I said.

When he went away, she declared. "It's not much fun conversing with an unhappy mirror."

"Discontented mirror," I corrected.

"You might as well be a plate, because for the moment you reflect nothing, though I thought I saw a hint of me reflected there a half hour ago."

"Let's go to bed and dive right to sleep and strive for a better day tomorrow," I said flatly. "A day of fasting, a day without food or art, without conversation, even."

"And let's purge all thoughts, as well, let's wash clean the slate," she said. "Not even talk," she prescribed. "Mute, silent, empty, then let's start afresh, a bright mirror and a sharp slice of cheese," she added, as we rose in the elevator.

"*Da cord*," I said, holding her to me once we slid into bed. We kissed on the cheeks and held hands, like the old friends, after all the years, we had become.

"*Bone nooey*," she said, letting out a dainty sigh into her pillow.

Sometime in the night, I woke and went up to the window and faced the museum, where whole lives

were resting on the walls, paintings, any one of which I would have gladly exchanged years of my life to have painted. Five years for Goya's dog staring, with all the might of his dog's soul, into space, seeing in the air what invisible presences no humans have the eyes to see.

Ten years I'd give—fifteen even—for Velasquez's *Las Meninas*, where in a darkened room, a cave of royals, King and Queen are framed in a distant mirror, and princess and her ladies-in-waiting, dwarfs and a sturdy dog sit for their portrait, the artist viewing them in a mirror and watching himself in another mirror painting them. Velasquez had conceived the world as an ungraspable reflection of mirrors, endlessly reflecting and refracting analogies back and forth through time and place. I was sure that eventually, one day in eternity, I would look at the painting and see myself and my darling bears cavorting in a mountain stream at the canvas edge.

I returned to bed where, as elsewhere, nothing of mine had ever flowered, except my dreams. And soon I slept and soon I dreamed.

My bears were home, back in the circus again, performing acts of their own invention. Befitting the true artists they had become, their heads were mirrors, but unlike mine, their mirrors reflected everything about them, and absorbed everything about them, the whole giant red tent and the world beneath it, lions, seals, elephants, the large wheels of cheese being rolled on their side by chimps with hats topped with salmons smoking cigars. Reflected, even, a troupe, all in plaid bow ties, of dancing green snakes from our old mountains—their mouths no longer frothing—dancing their elastic skinny dance.

The audience shone in their mirrors, too: Children with eyes open wider than the sky at night; adults healthy and dying indifferent to their fate; lovers pausing in their lust; moms and dads sweating gladly in their Sunday best, staring enviously at the family of happy bears, happy as families never are. And I was there, caught in their mirrors as well. Me, alone, at night, in the shadow of a museum the size of a mountain, in a moonlit cave in a graveled garden, at a table with a red umbrella, at a table humming with eyes.

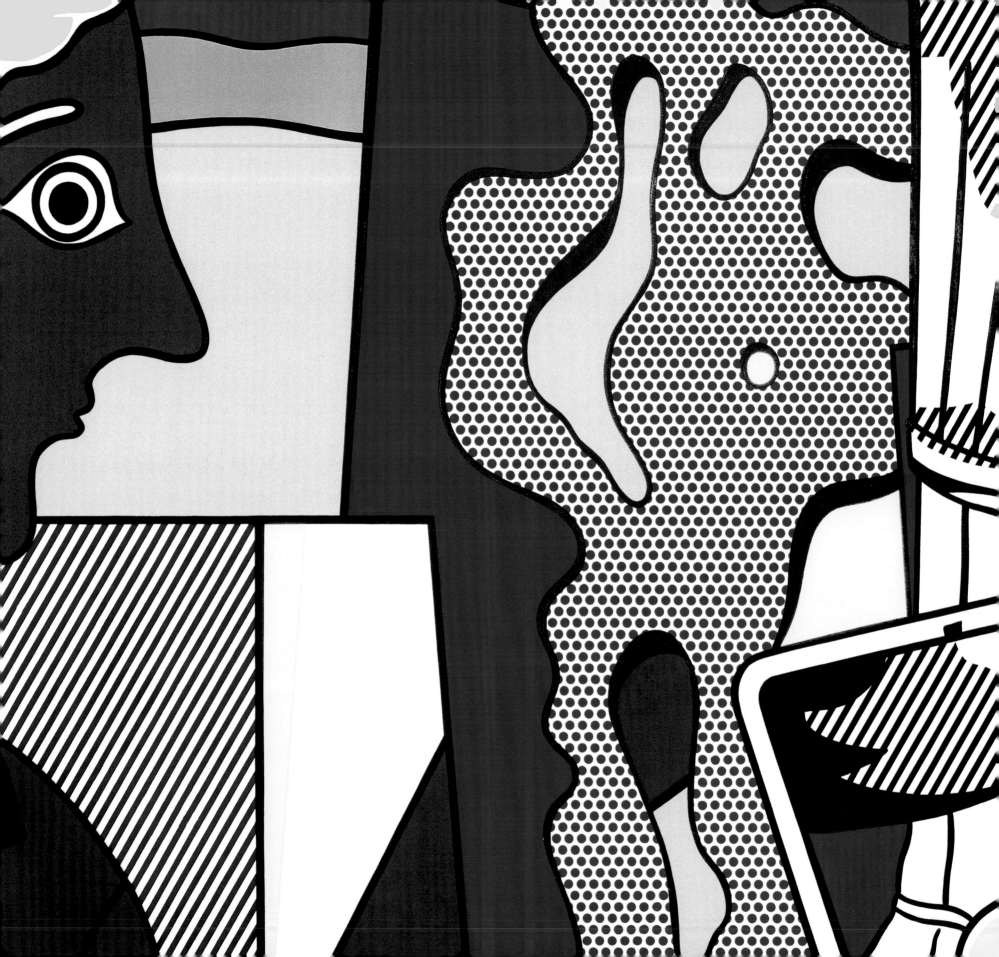

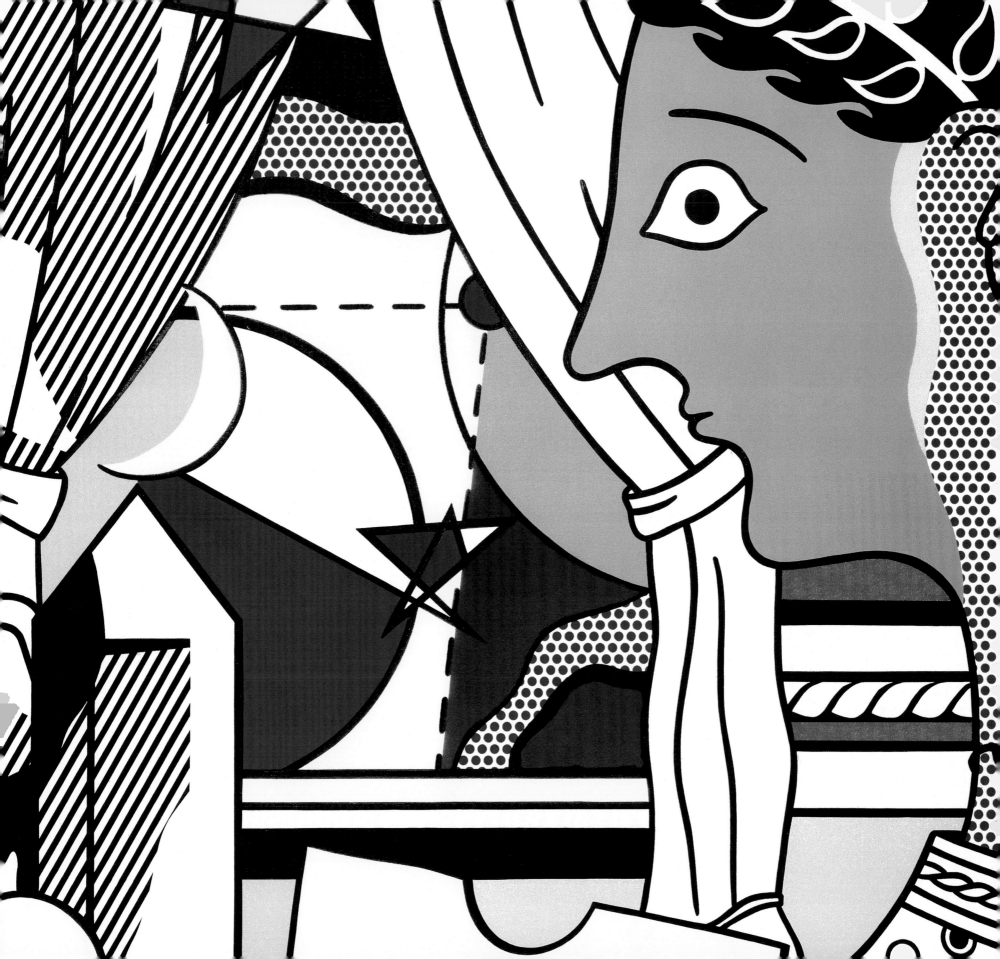

LIST OF DRAWINGS

1 **Untitled (figures in a garden)**
1949, signed
Pen and ink on paper
5 7/8 x 6 in. 14.9 x 15.2 cm

2 **Drawing for *Girl with Beach Ball III***
1976, signed and dated on the reverse
Graphite and colored pencils on paper
8 3/16 x 5 1/4 in. 20.8 x 13.3 cm
National Gallery of Art, Washington DC
Gift of Dorothy Lichtenstein and David and Mitchell
Lichtenstein in memory of Jane B. Meyerhoff, 2005

3 **Drawing for *Girl with Beach Ball II***
1976, dated on the reverse
Graphite and colored pencils on paper
5 13/16 x 3 9/16 in. 14.8 x 9 cm

4 **Drawing for *Female Figure on Beach* (detail)**
1977
Graphite and colored pencils on paper
5 3/4 x 3 3/4 in. (irregular) 14.6 x 9.5 cm (irregular)

5 **Drawing for *Nude on Beach***
1977, dated on the reverse
Graphite and colored pencils on paper
5 7/8 x 3 5/8 in. (irregular) 14.9 x 9.2 cm (irregular)

6 **Drawing for *Landscape with Figures***
1977, signed and dated on the reverse
Graphite and colored pencils on paper
20 x 27 1/2 in. 50.8 x 69.9 cm

7 **Drawing for *La La La!***
1977, dated on the reverse
Graphite on paper
5 13/16 x 3 5/8 in. 14.8 x 9.2 cm

8 **Drawing for *La La La!***
1977, signed and dated on the reverse
Graphite and colored pencils on paper
12 1/16 x 8 1/2 in. 30.6 x 21.6 cm

9 **Untitled (surrealist series)**
1977, dated on the reverse
Graphite on paper
10 x 6 3/4 in. 25.4 x 17.1 cm

10 **Drawing for *Frolic***
1977, signed and dated on the reverse
Graphite and colored pencils on paper
6 7/8 x 5 5/16 in. 17.5 x 13.5 cm

11 **Drawing for *Female with Comet***
1977, signed and dated on the reverse
Graphite and colored pencils on paper
23 1/2 x 19 7/8 in. 59.7 x 50.5 cm

12 **Drawing for *Reclining Bather***
1976, dated on the reverse
Graphite and colored pencils on paper
5 x 5 3/4 in. 12.7 x 14.6 cm

13 **Drawing for *Reclining Bather***
1976, dated on the reverse
Graphite and colored pencils on paper
8 1/4 x 11 5/8 in. (irregular) 21 x 29.5 cm (irregular)

14 **Drawing for *Figures in Landscape***
1977, signed and dated on the reverse
Graphite, colored pencils and collage on paper
12 1/8 x 9 1/16 in. 30.8 x 23 cm

15 **Drawing for *Figures in Landscape***
1977, signed and dated on the reverse
Graphite and colored pencils on paper
22 1/2 x 27 3/4 in. 57.2 x 70.5 cm
Whitney Museum of American Art, New York; Purchase, with
funds from the Drawing Committee

16 **Drawing for *Reclining Nude***
1977, signed and dated on the reverse
Graphite and colored pencils on paper
12 1/8 x 9 1/8 in. (irregular) 30.8 x 23.2 cm (irregular)

17 **Drawing for *Reclining Nude***
1977, signed and dated on the reverse
Graphite and colored pencils on paper
22 1/2 x 30 in. 57.2 x 76.2 cm

18 **Drawing for *Self Portrait***
1978, dated on the reverse
Graphite and colored pencils on paper
9 1/16 x 9 13/16 in. 23 x 24.9 cm

19 **Drawing for *Portrait* (detail)**
1978, signed and dated on the reverse
Graphite and colored pencils on paper
5 9/16 x 7 9/16 in. 14.1 x 19.2 cm

20 **Drawing for *Portrait***
1977, signed and dated on the reverse
Graphite and colored pencils on paper
6 5/16 x 5 1/2 in. 16 x 14 cm

21 **Drawing for *Razzmatazz***
1978
Graphite and colored pencils on tracing paper
19 x 24 1/8 in. 48.3 x 61.3 cm
National Gallery of Art, Washington, Gift of
Dorothy Lichtenstein and David and Mitchell Lichtenstein
in memory of Jane B. Meyerhoff 2005

22 **Drawing for *Razzmatazz***
1978
Graphite and colored pencils on paper
20 5/8 x 29 3/4 in. 52.4 x 75.6 cm.
National Gallery of Art, Washington, Gift of
Dorothy Lichtenstein and David and Mitchell Lichtenstein
in memory of Jane B. Meyerhoff 2005

23 **Drawing for *Two Figures; Two Figures; IX by XII
(rug design)* and Untitled (surrealist series)**
1977, signed and dated
Ballpoint on Stanhope Hotel stationary
7 1/4 x 10 7/16 in. 18.4 x 26.5 cm

24 **Drawing for *Figure with Rope***
1978, signed and dated on the reverse
Graphite and colored pencils on paper
11 1/2 x 7 1/4 in. 29.2 x 18.4 cm

25 **Drawing for *Two Figures***
1977, signed and dated on the reverse
Graphite and colored pencils on paper
5 3/16 x 5 5/8 in. 13.2 x 14.3 cm

26 **Drawing for *Two Figures* and Untitled (surrealist series)**
1977, dated on the reverse
Graphite and colored pencils on paper
5 3/4 x 3 3/4 in. 14.6 x 9.5 cm

27 **Drawing for *A Bright Night***
1977, signed and dated on the reverse
Graphite, colored pencils and collage on paper
9 1/16 x 6 5/16 in. 23 x 16 cm

28 **Drawing for** *At The Beach*
1978, signed and dated on the reverse
Graphite and colored pencils on paper
5 1/4 x 8 in. 13.3 x 20.3 cm

29 **Drawing for** *Woman with Flower*
1978, dated on the reverse
Graphite and colored pencils on paper
12 5/8 x 7 3/16 in. 32.1 x 18.2 cm

30 **Drawing for** *Figure with Banner*
1978, dated on the reverse
Graphite and colored pencils on paper
12 11/16 by 7 3/4 in. 32.2 by 19.7 cm

31 *Untitled (surrealist series)*
1977, dated on the reverse
Graphite on paper
11 3/8 x 8 1/8 in. 28.9 x 20.6 cm

32 **Drawing for** *The Conversation*
1977, signed and dated on the reverse
Graphite and colored pencils on paper
10 13/16 by 7 5/8 in. 27.5 by 19.4 cm

33 **Drawing for** *Figures*
1978, signed and dated on the reverse
Graphite and colored pencils on paper
7 1/4 x 5 9/16 in. 18.4 x 14.1 cm

34 **Drawings for** *Figure in Landscape*
1977, dated on the reverse
Graphite and colored pencils on paper
5 13/16 x 3 11/16 in. 14.8 x 9.4 cm

35 **Drawings for** *Figures in Landscape and The Conversation*
1977, signed and dated on the reverse
Graphite and colored pencils on paper
12 x 9 in. 30.5 x 22.9 cm

36 **Drawings for** *Those Two and Nerts*
1978, signed and dated on the reverse
Graphite and colored pencils on paper
12 1/16 x 7 5/8 in. 30.6 x 19.4 cm

37 **Drawing for** *Puzzled Portrait*
1978, dated on the reverse
Graphite and colored pencils on paper
12 5/8 x 7 3/4 in. 32.1 x 19.7 cm

38 **Drawings for** *Untitled Composition and Sitting Pretty*
1978, signed and dated on the reverse
Graphite and colored pencils on paper
10 7/8 x 7 1/8 in. 27.6 x 18.1 cm

39 **Final Drawing for** *Cosmology*
1978, signed and dated on the reverse
Graphite and colored pencils on paper
25 x 29 3/4 in. 63.5 x 75.6 cm
Museum of Modern Art, New York
Gift of the Lauder Foundation

40 **Drawing for** *Go For Baroque*
1979
Graphite and colored pencils on paper
5 7/8 x 8 11/16 in. 14.9 x 22.1 cm

41 **Drawing for** *Go for Baroque*
1979, signed and dated on the reverse
Graphite and colored pencils on paper
20 3/4 by 27 in. 52.7 x 68.6 cm

LIST OF PAINTINGS

42 *Figures*
1977, signed and dated on the reverse
Oil and Magna on canvas
44 x 100 in. 111.8 x 254 cm

43 *Nude on Beach*
1977, signed and dated on the reverse
Oil and Magna on canvas
50 x 60 in. 127 x 152.4 cm
Collection Würth, Künzelsau (Germany)

44 *Landscape with Figures*
1977, signed and dated on the reverse
Oil and Magna on canvas
64 x 100 in. 162.6 x 254 cm

45 *Girl with Beach Ball II*
1977, signed and dated on the reverse
Oil and Magna on canvas
60 x 50 in. 152.4 x 127 cm

46 *Female Head*
1977, signed and dated on the reverse
Oil and Magna on canvas
60 x 50 in. 152.4 by 127 cm

47 *Portrait*
1977, signed and dated on the reverse
Oil and Magna on canvas
60 x 50 in. 152.4 x 127 cm

48 *Self Portrait*
1977, signed and dated on the reverse
Oil and Magna on canvas
70 x 54 in. 177.8 x 137.2 cm

49 *La La La!*
1977, signed and dated on the reverse
Oil and Magna on canvas
75 x 44 in. 190.5 x 111.8 cm
Private Collection, courtesy Nancy Whyte Fine Art, Inc.

50 *Those Two*
1978, signed and dated on the reverse
Oil and Magna on canvas
50 x 76 in. 127 x 193 cm
Collection of Marieluise Hessel Artzt

51 *Landscape*
1977, signed and dated on the reverse
Oil and Magna on canvas
40 x 60 in. 101.6 x 152.4 cm

52 *Cosmology*
1978, signed and dated on the reverse
Oil and Magna on canvas
107 x 167 1/2 in. 271.8 x 425.5 cm

This catalogue was published on the occasion of the exhibition

ROY LICHTENSTEIN: CONVERSATIONS WITH SURREALISM

MITCHELL-INNES & NASH

Drawings:
September 19 – November 12, 2005
1018 Madison Avenue New York NY 10021

Paintings:
October 7 – November 12, 2005
534 West 26th Street New York NY 10001

Tel 212-744-7400 Fax 212-744-7401
info@miandn.com www.miandn.com

Design: Matthew Polhamus
Printing: Enterprise Press, NY

ISBN: 0-9749607-4-8

Available through D.A.P. / Distributed Art Publishers 155 Sixth Avenue 2nd Floor New York 1001 Tel 212-627-1999 Fax 212-627-9484

Cover: Roy Lichtenstein, *Figures*, 1977

Details of *Drawing for Reclining Nude*, 1977; *Girl with Beach Ball II*, 1977; *Self Portrait*, 1978; *Those Two*, 1978; *Cosmology*, 1978; *Landscape with Figures*, 1977; *Cosmology*, 1978

Charles Stuckey essay figure images:
1. Marcel Duchamp, Cover for the catalogue of the Man Ray Exhibition *Objects of My Affection*, Julien Levy Gallery, New York, April 1945, Philadelphia Museum of Art: Gift of Mme Marcel Duchamp, 1973, © 2005 Artists Rights Society (ARS), New York / ADAGP, Paris / Succession Marcel Duchamp 2. Salvador Dalí, Cover for *Dali on Modern Art (in French and English) Cuckolds of Antiquated Modern Art, the Artist's Commentary on Modern Art*, 1957, © 2005 Salvador Dali, Gala-Salvador Dali Foundation / Artists Rights Society (ARS), New York 3. Pablo Picasso, *Bather with a Beach Ball*, August 1932, The Museum of Modern Art, New York, NY, U.S.A., Partial gift of an anonymous donor and promised gift of Jo Carole and Ronald S. Lauder, Photo: © 2005 The Museum of Modern Art/Licensed by SCALA / Art Resource, NY, © 2005 Estate of Pablo Picasso / Artists Rights Society (ARS), New York 4. Roy Lichtenstein, *Girl with Ball*, 1961 5. Roy Lichtenstein, Cover for the catalogue of the exhibition *Art About Art*, The Whitney Museum of American Art, 1978 6. Roy Lichtenstein, *Crying Girl*, 1963-64 7. Man Ray, *Larmes (Tears)*, 1932-1933, The J. Paul Getty Museum, Los Angeles, © 2005 Man Ray Trust / Artists Rights Society (ARS), NY / ADAGP, Paris 8. René Magritte, *La Race blanche (The White Race)*, 1967, Photo: Banque d'Images, ADAGP / Art Resource, NY, © 2005 C. Herscovici, Brussels / Artists Rights Society (ARS), New York 9. Rene Magritte, *Le Fils de l'Homme (The Son of Man)*, 1964, Photo: Photothèque R. Magritte-ADAGP / Art Resource, NY, © 2005 C. Herscovici, Brussels / Artists Rights Society (ARS), New York 10. Marcel Duchamp, Cover for the catalogue *First Papers 1887-1968 of Surrealism*, 1942, Philadelphia Museum of Art: The Louise and Walter Arensberg Collection, 1950, © 2005 Artists Rights Society (ARS), New York / ADAGP, Paris / Succession Marcel Duchamp 11. Pablo Picasso, *Une Anatomie: Trois Femmes (Anatomy: Three Women)*, February 28, 1933, Musée Picasso, Paris, France, Photo: Réunion des Musées Nationaux / Art Resource, NY, © 2005 Estate of Pablo Picasso / Artists Rights Society (ARS), New York 12. Pablo Picasso, *Two Women looking at a Sculpted Head*, March 21, 1933, © 2005 Estate of Pablo Picasso / Artists Rights Society (ARS), New York

All Photographs of Roy Lichtenstein: Courtesy Roy Lichtenstein Foundation Archives
Roy Lichtenstein in his Southampton studio with *Cosmology*, 1978, Photographer Unknown; Roy Lichtenstein in front of *Frolic*, 1977, Photographer Unknown; Roy Lichtenstein working in his Southampton studio, Photographer Unknown; Roy Lichtenstein in his Southampton studio with *Portrait*, 1977 and *Landscape with Figures*, 1977, © 2005 Nancy Crampton

Plate photography by Kevin Ryan, Tom Powel Imaging, Inc., Gamma One Conversions and Robert McKeever

Mitchell-Innes & Nash would like to extend our gratitude to the Estate of Roy Lichtenstein and the Roy Lichtenstein Foundation, without whom this exhibition would not have been possible. We are enormously grateful to Dorothy Lichtenstein for her enthusiasm and generosity. We also thank Mitchell and David Lichtenstein and Renee Tolcott for their support. Jack Cowart, Cassandra Lozano, Natasha Sigmund, Shelley Lee, Clare Bell, Angela Ferguson and Bettina Utz have, once again, been significant collaborators. Their continuous efforts, research and contributions have been a critical part of the realization of this project. We are especially indebted to our lenders, including the National Gallery of Art, Washington, D.C., the Museum of Modern Art, New York, The Wurth Museum, Germany, Marieluise Hessel Artzt, Nancy Whyte and several private collectors who have lent important works from their collections in order to support this exhibition. We would like to thank our writers, Charles Stuckey and Frederic Tuten, for their contributions to the catalogue. Finally we would like to thank Dorothy Lichtenstein, Jack Cowart, the Roy Lichtenstein Foundation Board of Directors and Ohio State University for permission to publish for the first time Roy Lichtenstein's M.F.A. thesis submitted to Ohio State University in 1949.